WN

DATE DUE

DEMCO 38-297

REVEALING ANTIQUITY

· 16 ·

G. W. Bowersock, General Editor

G. W. BOWERSOCK

Mosaics as History

THE NEAR EAST FROM LATE ANTIQUITY TO ISLAM

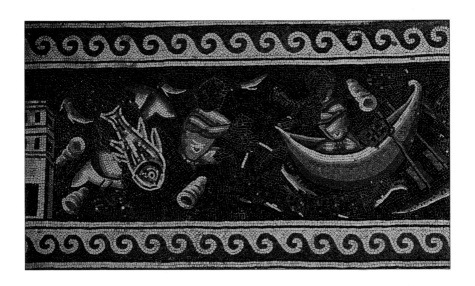

THE BELKNAP PRESS OF
HARVARD UNIVERSITY PRESS
Cambridge, Massachusetts
London, England
2006

Library of Congress Cataloging-in-Publication Data
Bowersock, G. W. (Glen Warren), 1936–
 Mosaics as history : the Near East from late antiquity to Islam /
G. W. Bowersock.
 p. cm.—(Revealing antiquity ; 16)
 Includes bibliographical references and index.
 ISBN-13: 978-0-674-02292-8 (alk. paper)
 ISBN-10: 0-674-02292-0 (alk. paper)
 1. Mosaics, Ancient—Middle East. 2. Middle East—Antiquities.
3. Middle East—History—To 622. I. Title. II. Series.

 NA3780.B69 2006
 738.509394—dc22
 2006041140

Preface

The chapters that follow derive, with the exception of the last, from a series of lectures delivered in March 1997 at the Collège de France in Paris under the general title of *Le Mystère de Grégoria: Mosaïques du Proche-Orient dans l'Antiquité Tardive*. I am indebted to my friend Marc Fumaroli for the invitation to deliver these lectures, and to his assistant Catherine Fabre for making the arrangements so efficiently. I am indebted as well to another friend, Gilbert Dagron, who introduced several of the lectures and provided important support throughout my month in Paris. Among the faithful auditors were still more friends who have long helped me in various ways: Janine and Jean-Charles Balty, Jean Leclant, Georges Le Rider, the much-missed Jeanne Robert, and Jacqueline de Romilly.

With the torrent of discoveries and publications on late-antique mosaics from the Near East in recent years, the preparation of this book took more time than anticipated. In addition I was agreeably diverted into a project with my Princeton colleagues and friends Peter Brown and Oleg Grabar to produce a substantial reference volume on late antiquity. Harvard University Press published this in 1999. After that came another di-

version in the form of a volume of selected papers on late antiquity that appeared in Italy (published by Edipuglia) in 2000.

The lengthy process of revising and augmenting my text for publication, together with compiling apposite illustrations, led to a decision to offer the book now in English. I have greatly benefited from extensive discussion with colleagues since 1997, especially with Zeev Weiss (who led me on an unforgettable tour of Sepphoris), with Guy Stroumsa, and with Garth Fowden. I have presented some of my material, at various stages of development, in Oxford, Jerusalem, and Budapest. A quarter-hour segment on National Public Television's four-part series on the Institute for Advanced Study (*Big Ideas;* 2003) was devoted to this work on Near Eastern mosaics. My immense gratitude to Father Michele Piccirillo OFM will be apparent everywhere in this book. His excavations in Jordan have produced discoveries that are fundamental to my argument. I am equally indebted to Zeev Weiss for his unfailing cooperation in supplying images of the magnificent mosaics at Sepphoris.

I am also indebted to Christopher Jones at Harvard for a critical reading of the penultimate draft of the entire manuscript, and to Peg Fulton and Maria Ascher at Harvard University Press for invaluable editing and support throughout. I am grateful to Jaś Elsner for very helpful suggestions.

It has been inevitable from the start that I would not be able to supply illustrations for every one of the images I discuss. I have tried to introduce images as historical documents in much the same way as inscriptions, coins, papyri, and literary texts. Where the full document cannot be examined here, there should nevertheless be enough information to justify its relevance and to guide the interested reader. This is essentially a historical inquiry, not a stylistic or aesthetic one. It is meant to evoke a rich and varied fabric of society, religion, and culture that could legitimately be claimed as late antiquity's most potent legacy to Islam.

Contents

1 Maps 1

2 Myths 31

3 Cities 65

4 Iconoclasms 91

5 Contexts 113

Bibliography 125

List of Illustrations 135

Index 141

MOSAICS AS HISTORY

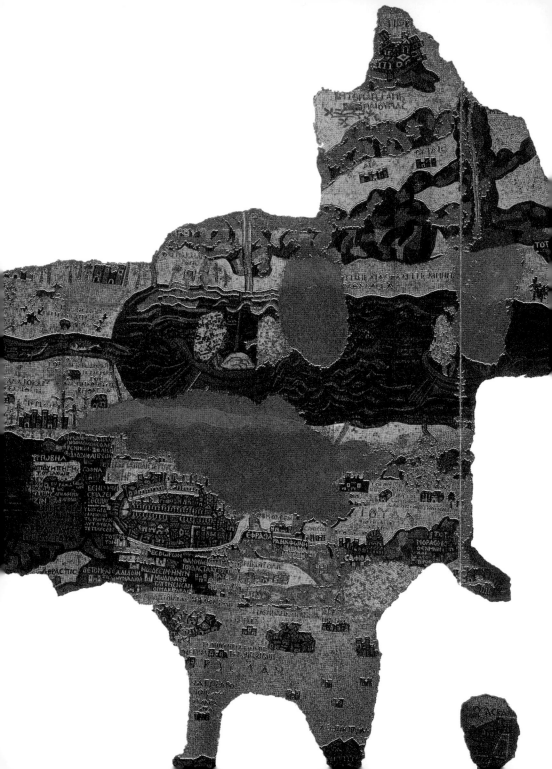

1

Maps

Toward the end of the nineteenth century the members of the Greek Orthodox community in the town of Madaba, in what is now the Kingdom of Jordan, launched the construction of a church, dedicated to Saint George, on the remains of the Byzantine basilica where they had been worshiping. In preparing the floor, the workmen made an astonishing discovery. At their feet they saw a large mosaic in the form of an illustrated map. It displayed emblematic representations of the major cities of the Near East, together with the principal features of the landscape. This map lay over a large part of the space immediately in front of the apse of the church. Two square supporting columns of the nave were implanted on top of it, and during their installation substantial parts of the mosaic were destroyed forever. But what survived was brought to the attention of the scholarly world by a visitor to the site in December 1896 (Figure 1.1).[1]

1. See Koikylidis, *Madaba Mosaic,* 1897; Lagrange, "La Mosaïque géographique," 1897; Germer-Durand, *La Carte mosaïque,* 1897. Bits of the mosaic had been observed in the foundation of the old church before 1890, but their significance had not been appreciated. Michele Piccirillo tells the story of this communication failure in his *Madaba,* 1989, p. 76, with the notes on p. 94.

1.1. THE FIRST PHOTOGRAPH OF THE MADABA MAP, TAKEN BY J. GERMER-DURAND IN MARCH 1897.

Not long afterward in the same city another mosaic that had turned up in work on a private dwelling suffered a similar mutilation. In this case it was not because of the exigencies of architectural design but solely because Christians in the region found it lewd. Exuberant images of Ariadne, a Bacchant, and a satyr were attacked, and the figure of Ariadne was lost forever (Figure 1.2).[2] At the end of the nineteenth century mosaics in the Near East were not treated as a precious part of the documentation of its ancient culture, as were literary texts, inscriptions on stone, coins, and architectural remains. Art historians, social historians, and religious historians paid them little attention and often treated them as

2. Piccirillo, *Madaba*, 1989. The image is also reproduced in Piccirillo, *Mosaics of Jordan*, 1993; and idem, *Arabia cristiana*, 2002.

MAPS

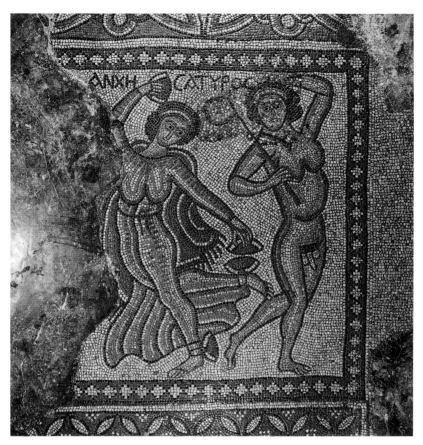

1.2. BACCHANT AND SATYR, ARCHAEOLOGICAL MUSEUM AT MADABA.

purely decorative. If the Madaba map fared better than most, after the disaster attendant upon its discovery, this was largely because it included a remarkably prominent picture of Jerusalem.[3]

More mosaics uncovered in the Near East in the first half of the twentieth century suffered comparable neglect. Hardly anyone noticed the

3. Lagrange, "Jérusalem," 1897,

exceptional pieces found in Shahba (Philippopolis) in about 1928, and similar inattention greeted the mosaics turned up by the first Belgian expedition to Apamea in Syria in the 1930s. Janine Balty, who has worked with great success alongside her husband in the current Belgian excavations at Apamea, has been a pioneer in interpreting Eastern mosaics, both at that site and throughout the whole region, as new and eloquent expressions of late-antique culture.[4] She has rightly emphasized the work of Doro Levi on the mosaics of Syrian Antioch, published in Princeton soon after the Second World War, as constituting a watershed in the study of such documents. Yet as late as 1966 Philippe Bruneau could still entitle an article on the evidence of mosaics, "Perspectives on a Field of Ancient Art Still Poorly Explored."[5]

In the following decades an avalanche of new discoveries was to break open the dam of ignorance and neglect, and to lay before historians of all kinds an immense treasure of new testimony from antiquity. Social and religious historians have barely begun to absorb the impact of what Denis Feissel, in an article on the work of Pauline Donceel-Voûte on the Byzantine church pavements in Syria and Jordan, has recently called "the accelerated pace of mosaic discoveries, largely church mosaics."[6]

Major documents in mosaic form have now been unearthed in Israel (at Sepphoris and Hammat Gader), in Syria (especially at Antioch, Apamea, and Sarrin), and in Jordan, where the new material has come forth in almost embarrassing abundance.[7] At Madaba the excavations of the Rev. Michele Piccirillo, in collaboration with the Jordanian Department of Antiquities, have fully confirmed the impression of the earlier

4. J. Balty, *Mosaïques antiques,* 1995; on Doro Levi, see p. 111.

5. D. Levi, *Antioch Mosaic Pavements,* 1947. Cf. Bruneau, "Perspectives," 1966. As late as 1998 Muth could write of the relative marginalization of domestic mosaics in North Africa and Spain for historical and cultural studies (*Erleben von Raum,* pp. 27–30).

6. Feissel, "L'Epigraphie des mosaïques d'églises," 1994, p. 286.

7. See the bibliographies in Balty, Hirschfeld, Kondoleon, Piccirillo, and Weiss.

chance finds at that city. This was a place uncommonly rich in mosaics that challenge historians of religion and society no less than historians of art. Subsequent work carried out by Father Piccirillo, with an innate instinct for buried churches that his closeness to divine power seems to have miraculously fortified, uncovered wondrous pavements at the modern Jordanian town of Umm er-Rasas—mosaics that take us by a manifestly unbroken tradition from late antiquity deep into the Islamic era.[8] Other Jordanian cities, such as Jerash (Gerasa) and Maʻin, have also contributed to the wealth of documentation from the ancient provinces of the region, known as Arabia and Third Palestine (Palaestina Tertia). Never before has the relation of individual cities to the other cities in their cultural sphere been so vividly illustrated.

Clearly the moment is at hand for a more comprehensive examination of this rich new evidence for life and belief in the pullulating late-antique Near East. These mosaics are historical documents that are no less precious and informative than literary texts, inscriptions, coins, sculptures, and buildings. With the indigenous Semitic traditions of the region, extending back to Jewish and Samaritan settlements in Palestine, to the Palmyrene empire in Syria, and to the Nabataean kingdom in Jordan, the overlay of Hellenism introduced by Alexander the Great as well as Roman customs imported by the imperial legions created a complex fusion of cultures and religions. The arrival of Islam in the seventh century only enriched this extraordinary mix. The mosaics eloquently evoke a shared vision of a world beyond the boundaries of individual cities. They illustrate a persistent tradition of Greek taste that could embrace Judaism, Christianity, and Islam in a fundamentally Semitic land, and they suggest the extent to which these three monotheist religions could themselves embrace Hellenism.

If the extant mosaic documentation suggests that in the fifth and sixth

8. Piccirillo with Alliata, *Umm al-Rasas, Mayfaʻah,* 1994.

centuries, and even later, the territory of Jordan was more productive than previously, whereas Syria seems more prominent before that, we should be slow to assume that there was any interruption or meaningful transition in the centers of mosaic art. We are still at the mercy of our finds, which continue to come forth every year. Janine Balty has recently argued against the notion of some kind of Justinianic renaissance, such as has been proposed in certain contributions to Father Piccirillo's general book on the new mosaics of Jordan.[9] Continuity makes a far more reasonable hypothesis, although it will be clear that continuity did not preclude innovation.

In fact, if we accept the general view that Justinian was not much interested in Third Palestine and preferred to leave the management of the region to local sheikhs called phylarchs, we are compelled to believe that what happened in Jordan between the fifth and the eighth centuries had nothing much to do with Byzantine imperial initiatives. It similarly seems to have had little to do with the aspirations of the Umayyads after the Muslim conquest in the seventh century. Not until faces were gouged out of some of the mosaics a century later can we be sure that some external force was driving the religious engine of these Near Eastern cities. Even when that happens, we remain in the dark about the agents who defaced the works. Whether we adopt Father Piccirillo's discreet and politically correct term "iconophobia," or make do with the traditional word "iconoclasm," there is no doubt that Jews, Christians, and Muslims were, for a time, in the business of removing representational images.

Like the pagan Symmachus, who, in the face of burgeoning Christianity, claimed that there was more than one way to the *grande secretum*, these new mosaics can be approached by many paths.[10] In this investiga-

9. J. Balty, *Mosaïques antiques,* 1995.
10. Symmachus, *Relationes,* 3.10: "Uno itinere non potest perveniri ad tam grande secretum."

tion we shall look first at the identity of cities in the context of their symbolic representation and imaginative cartography. This will takes us directly to the Madaba map, which, with its beguiling evocations of the cities it names and its reminders of edifying tales associated with the region, provides the basic frame for what follows. We shall start with a relatively new and enigmatic image that remains as mysterious now as it was when it was discovered. But the process of trying to understand it can be instructive in addressing larger issues. For we confront here a transparently great and famous city that bears a name no one had ever seen attached to any city before.

It was in 1982 that Father Piccirillo exposed the mosaic in question. It was found in what is now known as the Room of Hippolytus at Madaba. The pavement probably adorned some kind of private dwelling, although a municipal building obviously cannot be ruled out. It lay beneath the vestibule and narthex of the city's Church of the Virgin, where there had been earlier excavations at the beginning of the twentieth century. These had exposed the lower part of an underlying pavement up to the point where a wall had been constructed across it. Piccirillo uncovered a mosaic which had been partly eliminated by the wall. We therefore enter the pavement halfway into a busy representation of the story of Phaedra and Hippolytus (Figure 1.3). The lovesick stepmother is accompanied by servants, and Hippolytus, now missing altogether, was evidently preparing to go on a hunt. He was surrounded by an old nurse and a slave. It is clear that in the late-antique world the story of Phaedra enjoyed a popularity exceeded, perhaps, only by that of those two universalizing figures, Dionysus and Heracles, who both made the world a theater for their exploits. But we shall reserve the myths themselves for a subsequent chapter once we have reviewed the milieu that cultivated them.

Above the panel of Phaedra is a lively scene of an innocently erotic character, with Aphrodite, Adonis, the Graces, a farmer with provisions for them all, and mischievous Erotes, one of whom has got stuck in a

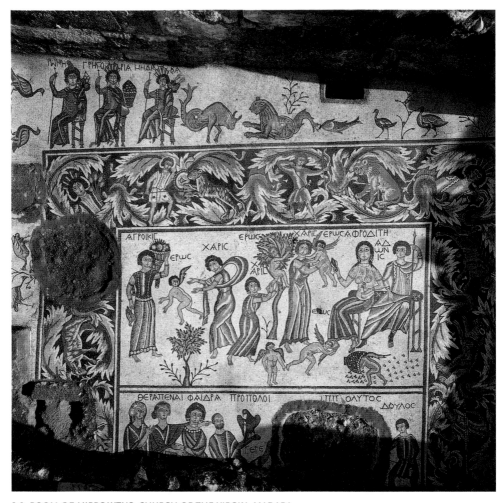

1.3. ROOM OF HIPPOLYTUS, CHURCH OF THE VIRGIN, MADABA.

beehive. Outside the frame lies an ebullient border of hunters and animals, with crowned figures of "fortune" known as *tychai* at the corners. Above all this appears a stately trio of personifications of identified cities, *tychai* of Rome, Gregoria, and Madaba. Although Madaba is clearly present because the mosaic was created in and for Madaba, the other two cit-

ies with which it is immodestly conjoined are obviously meant to be important places. One is identified as Rome, the other mysteriously as Gregoria.

Now, the greatest cities of the Mediterranean world in late antiquity, as we learn from the four famous statuettes in the Esquiline Silver Treasure (Figure 1.4) and from such writers as Ammianus Marcellinus and Libanius, were Rome, Constantinople, Antioch, and Alexandria.[11] When the group was narrowed to a triad on the Peutinger Table, a medieval copy of a late-antique map, the cities were Rome, Constantinople, and Antioch. In this mosaic an inventive and patriotic mosaicist has replaced one of the canonical three with Madaba and introduced a city called Gregoria, which the rhetoric of the image proclaims to be a great city comparable to Rome. What is going on here? The excavator, and now recently Janine Balty, consider Gregoria an otherwise unknown name for Constantinople, although they would undoubtedly agree that this is hardly certain. Gregoria is a mystery that lies at the core of the present inquiry. If, as archaeologists and art historians all agree, this mosaic is a work of the middle to late sixth century, we have here an astonishingly vigorous creation that opens up a world for which one of its greatest cities is obscure to us. Yet the icon of that city attends the representation of a famous Greek myth and assorted Greek divinities. This is a world that contained both old traditions and new identities. When, in the early seventh century, the Persians invaded it and the Muslims conquered it, they absorbed both.

The evocation of cities of the "inhabited world" *(oikoumenê)* has, in recent decades, emerged as a particular preoccupation of the early Byzantine Near East. Mosaic panels at Gerasa, Khirbet as-Samra, and Ma'in

11. On the Esquiline Treasure and the four cities, see Kondoleon, *Antioch,* 2000, pp. 116–117. See also Ammianus Marcellinus, 22.16.7, on Alexandria as the crown of all cities; and Libanius, *Orationes,* 11 *(Antiochikos)* on the glory of Antioch.

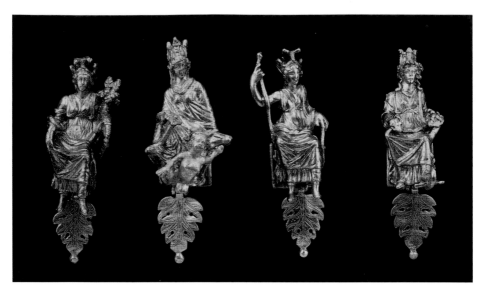

1.4. ESQUILINE STATUETTES: FROM LEFT TO RIGHT, CONSTANTINOPLE, ANTIOCH, ROME, ALEXANDRIA.

from roughly the same period as those at Madaba present vivid images of urban agglomerations. Buildings are clustered in distinctive and realistic forms to identify various cities of the region. So, for example, in the Church of St. John at Gerasa we see a church and secular buildings at Alexandria in a style not unlike that of comparable city representations of somewhat later date in the Church of St. John at Khirbet as-Samra (Figure 1.5). These images are far more detailed and less obviously symbolic than the traditional vignettes of walled cities and camps known from the manuscripts of the Agrimensores and the Notitia Dignitatum.[12] A whole series of city mosaics at Ma'in shows, as we shall see, highly individualized buildings in Alexandria, Characmoba, Areopolis (Rabba), Gadoron, and Esbous.[13] Such local enthusiasm for the cities of the eastern em-

12. Levi and Levi, *Itineraria Picta*, 1967.
13. Piccirillo, *Mosaics of Jordan*, 1993, pp. 194–204.

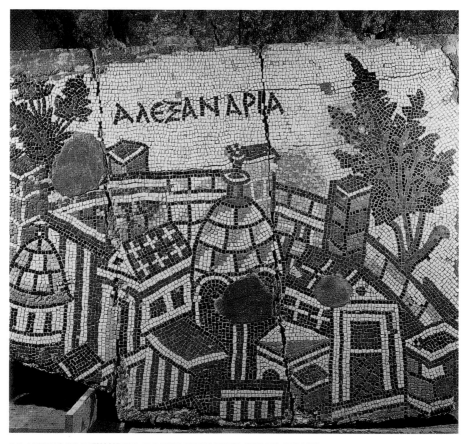

1.5. MOSAIC OF ALEXANDRIA, CHURCH OF ST. JOHN, GERASA (JERASH).

pire provides a visual commentary on those three personified cities of Madaba.

All this material finds a startling resonance in the newly discovered mosaics in the Church of St. Stephen at Umm er-Rasas from the eighth century, about a century after the Muslim conquest. The detailed mosaic panels of cities on the principal mosaic show that preoccupation with urbanism in the sixth and seventh centuries continued unabated under

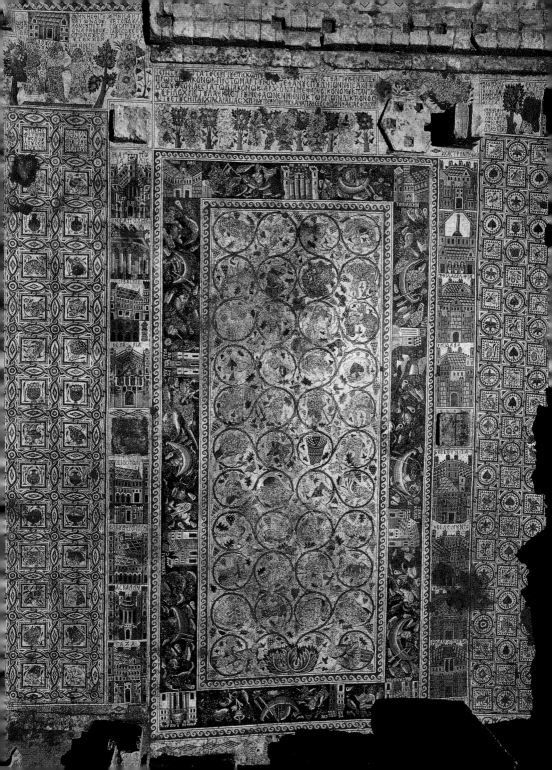

Muslim rule (Figure 1.6). The style remained representational in exactly the same way, and images were accompanied by an explanatory text in Greek. We can be in no doubt that we are in the presence of a strong and important tradition.

The cities depicted at Gerasa, Khirbet as-Samra, Ma'in, and now Umm er-Rasas naturally send us back to the famous map at Madaba (Figure 1.7). Even in its fragmented condition it is an invaluable document for the late-antique East. The viewer, or perhaps it would be better to say reader, of the map must be conceived as standing squarely in the Mediterranean Sea off the coast looking eastward toward Palestine. The physical geography is represented with skill and humor. The landscape is full of cities and villages, many of which remain unknown to this day. Three settlements, or possibly forts, in the Araba depression south of the Dead Sea mark way-stations on the road that linked the Negev with Transjordan. East of the Dead Sea are the hills that separate it from the great city of Characmoba (Kerak), shown on its rocky promontory with a cluster of buildings. The Nile Delta is a busy patchwork of waterways and settlements, large and small, known and unknown. Pelusium has a prominence that matches what we know of its role in the Delta. In the Negev itself edifying inscriptions evoke stories that relate to the region—for example, "Raphidim where Amalek came and fought with Israel."

Finally, Jerusalem: the depiction is sumptuous and shows recognizable features of the city, such as the Damascus Gate and the Church of the Anastasis (Figure 1.8). The map at Madaba shows the cities, villages, and forts all in relation to each other and with representations to suggest their size (and perhaps character). The map instructs the viewer through its legends, and it is, as a mosaic should be, a pleasure to behold.

Ever since the earliest publications of this map by Kleopas Koikylidis

1.6. OVERVIEW OF THE GREAT MOSAIC IN THE CHURCH OF ST. STEPHEN, UMM ER-RASAS, WITH CITIES IN THE BORDERS OF THE CENTRAL CARPET.

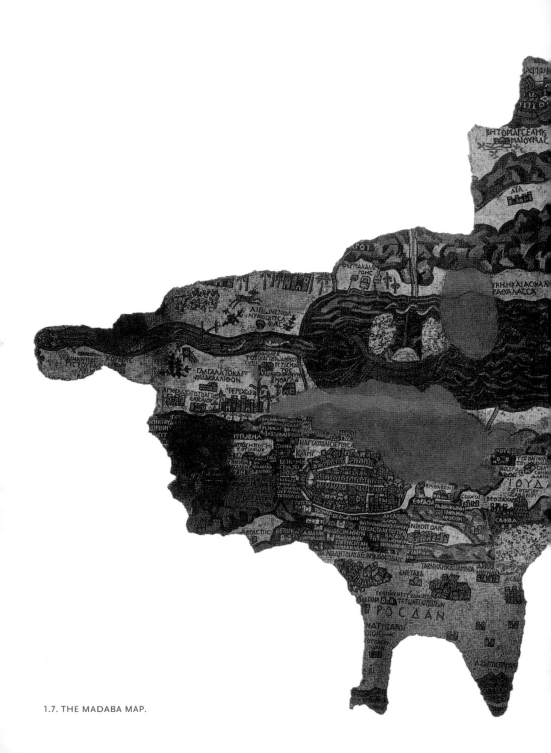

1.7. THE MADABA MAP.

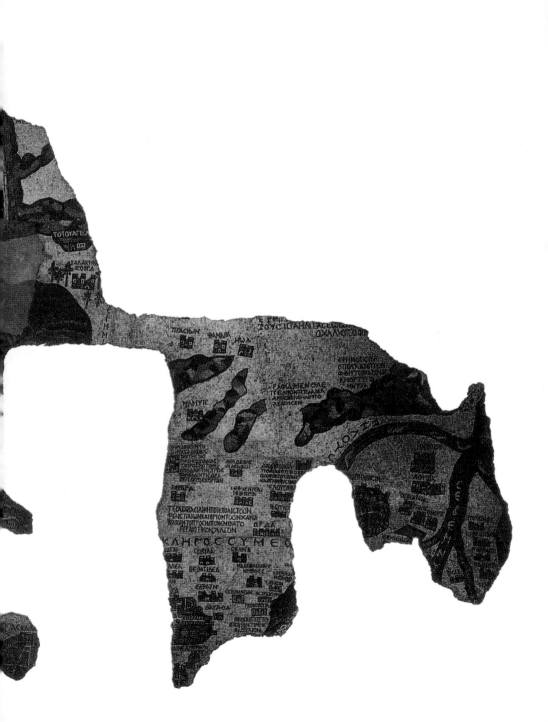

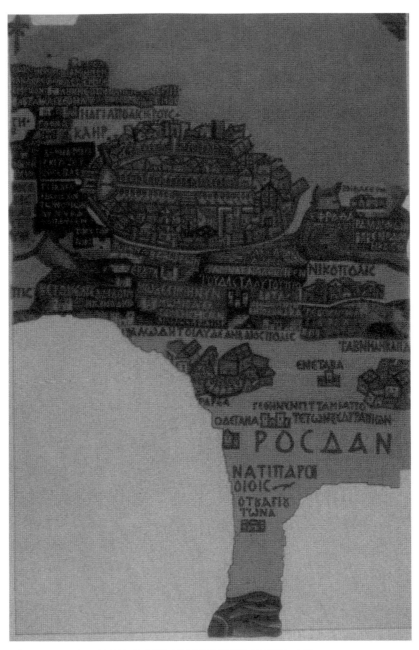

1.8. VIGNETTE OF JERUSALEM WITH ADJACENT CITIES, MADABA MAP.

and Marie-Joseph Lagrange at the end of the nineteenth century, interpretation of this document has been based upon two fundamental premises that have never been seriously brought into contention.[14] The first is that the purpose of the map was instruction in the principal sites and toponyms of the Bible, and the second is that the maker of the map depended directly and largely upon the *Onomasticon* of Eusebius. The twin assumptions of scriptural exegesis and Eusebian source have made it difficult for scholars to comprehend or accept the tantalizing reports, conveyed by Koikylidis and Lagrange, that the earliest witnesses of the map, before it was partially destroyed, maintained that it extended over a region so large as to include Ephesus, Smyrna, and Constantinople. Michael Avi-Yonah, in his edition of the document, expressed the general opinion when he wrote, "It was obviously intended to show Bible lands," and therefore concluded that it could not have depicted anything above the southern part of Syria and certainly not Asia Minor. Pierre-Louis Gatier had, however, the courage to observe in his commentary on the map's inscriptions, included in his volume for the series of Greek and Latin inscriptions of Syria (obviously broadly understood), "In our opinion the presence of sites in Asia Minor is not to be excluded so fast, and, besides, Avi-Yonah's reconstruction is very doubtful. The question remains open."[15]

Biblical content and Eusebian origin are inextricably linked. Eusebius' *Onomasticon* was nothing more nor less than a register of biblical sites. Its preface discloses that its alphabetical register, or more properly gazetteer, is only the fourth and final part of a larger work. The earlier parts, although now lost, must have provided the justification for the material included in the gazetteer. It is clear that Eusebius had first converted into

14. Koikylidis, *Madaba Mosaic*, 1897; Lagrange, "La Mosaïque géographique," 1897.

15. Avi-Yonah, *Madaba Mosaic Map*, 1954; and Gatier, *Inscriptions de la Jordanie*, 1986, no. 153 (la carte de Madaba), pp. 148–180. The citation comes from p. 178.

Greek the Hebrew names for all the peoples named in the Bible. He had then made what he calls a *katagraphê* of biblical Judaea and distinguished the territories of the twelve tribes. Next he had provided a detailed account of the holy city of Jerusalem itself, with appended commentaries on its various monuments and places. Only after this was he ready to compile the *Onomasticon,* providing—one name at a time— the significance of the Hebrew places, their location, and their current Greek names. The problem of what exactly the original *katagraphê* of Judaea was has aroused much debate over the past century. Several eminent scholars, such as Charles Clermont-Ganneau and José O'Callaghan, have argued that the word proves that Eusebius had himself constructed a map of the region that must have served as a model for the Madaba mosaicist.[16] Although it is not easy to imagine Eusebius engaged in mapmaking, his words about the description of Jerusalem have served regrettably to suggest this. Of this *great metropolis* of the Jews he claimed that he was describing the look of the city, but he used the terms *eikon* for representation and *diacharaxas* for the act of describing. But in fact, this proves nothing about making a map. The language is standard terminology for ecphrastic writing—a genre of verbal description that was analogous to painting and that was much in vogue in the Roman imperial period. The literal sense of cutting or engraving in the participle *diacharaxas* could hardly be applied to the *eikon* itself. The Greek implies no more than the sense of "depict." Nonetheless, the idea of a Eusebian *Urkarte* persists.

This is a great pity, because no one seems to have looked closely enough at the more than 150 items to be found on the Madaba map. Less than 20 percent of them can be paralleled in the *Onomasticon* of

16. For current discussion, see Piccirillo with Alliata, *Madaba Map Centenary,* 1999. The Franciscans have developed an excellent website: http://servus.christusrex.org/www1/ofm /mad/index.html. I am grateful to Christopher Jones for drawing this site to my attention.

Eusebius. Allowing for a few uncertainties, we can say that approximately twenty-five sites on the map recur in the *Onomasticon*. Fewer than that have demonstrable affinities to what is said there. Clearly there is some connection with the Eusebian tradition, as a shared error concerning the baptism of the eunuch of Candace or the report on the site of Suchem makes plain. The interpretation of Akrabbim on the map coincides with the text of Eusebius. In addition, a small number of places appear in both documents but without proof that any one was taken from the other. But the vast majority of sites on the Madaba map have no point of contact whatever with Eusebius' work. This ought not to be surprising, since the *Onomasticon* was two hundred or more years old when the map was created. The fundamental character of the map is its lively interest in the contemporary region. Its occasional biblical exegesis does not go much farther than what we find in the Peutinger Table, and that is something everyone agrees to be an essentially secular document based on a road map. Even so, Moses is commemorated there.

A comparison with overtly instructive material from the Bible presented for the edification of churchgoers demonstrates just how far removed the Madaba mosaic is from any such purpose. In the basilica of Damokratia at Demetrias in Thessaly, wall paintings with painted inscriptions survive in fragments from the end of the fifth century. Meticulously published by Christian Habicht, they combine images from biblical stories with quotations from the Bible itself.[17] As Habicht noted, these quotations are normally word-for-word or with only slight variants. He is able to piece together a representation of Jacob's ladder, for example, with a painted inscription that is obviously adapted from the Septuagint text of the Book of Genesis. This kind of biblical image and citation is altogether absent from the mosaic map.

The Madaba configuration of cities, seen from the sea, more properly

17. Habicht, "Neue Inschriften aus Demetrias," 1987, pp. 269–306.

1.9. PEUTINGER
TABLE: VIGNETTE
OF ROME.

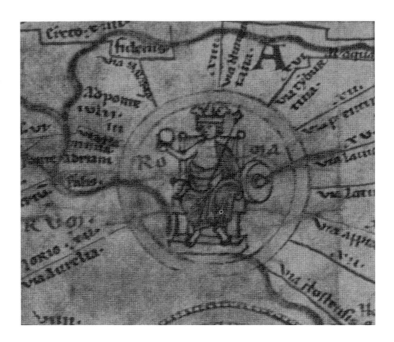

summons a comparison with that other great map of the late-antique world, the Peutinger Table.[18] This huge document is a twelfth- or thirteenth-century copy of an original that was undoubtedly compiled in the late fourth or early fifth century. It includes the same territory as the Madaba map, but in a more businesslike way. It marks roads, which may indeed have been the principal concern of the designer. Its artistic ambitions are modest, but once again cities and villages are signaled by symbolic representations that have largely the character of the vignettes in the Agrimensores manuscripts. Yet the three great cities of the empire, Rome, Constantinople, and Antioch, display magnificent personifications (Figures 1.9, 1.10, 1.11). Antioch on the map of Syria and Palestine brings us very close to the territory of the Madaba map.

18. Magnificently published in two volumes with a facsimile of the sheets and commentary by Weber in *Tabula Peutingeriana*, 1976.

1.10. PEUTINGER TABLE: VIGNETTE OF ANTIOCH.

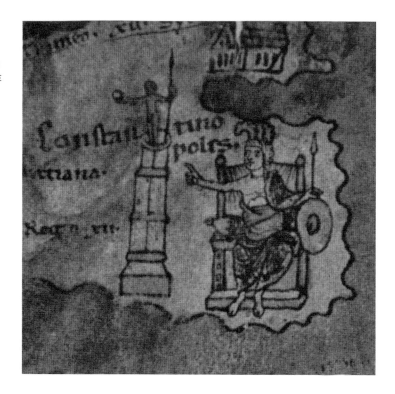

Those three city figures on the extant Peutinger copy appear to be em-
perors, but Gilbert Dagron is probably right to assume that on the origi-
nal map they were *tychai*, emblematic "fortunes" of each city, sitting on
their thrones.[19] Rome sits with an orb, scepter, shield, and crown, clearly
proclaiming the first city of the Roman world. By contrast, Constantino-
ple has a spear and a peculiar headpiece that is obviously not a crown,
perhaps some sort of Phrygian cap or possibly a helmet. The figure has
no orb but obligingly points toward a column surmounted by a statue

19. Dagron, *Naissance d'une capitale*, 1974. See also Bühl, *Stadtpersonifikationen*, pp.
107–142.

that does hold an orb. This column, as Dagron recognized in opposition to the Levis' peculiar assumption that it was a lighthouse, is unmistakably the well-known porphyry pillar that bore a statue of Constantine. Antioch sits with a spear and a splendid crown. The small person at the city's feet is less likely to be someone seeking protection than a simple personification of the Orontes River, on which Antioch was strategically situated. The Esquiline Antioch shows, for example, the city's *tyche* conspicuously seated on an outcropping of rock above the personification of the river (Figure 1.4). The three great cities stand out prominently from all other cities on the map, but they are manifestly different in their stylized features. The column at Constantinople and the mountainous side of the river at Antioch highlight known features of those cities.

Lesser cities have conventional icons to mark them. But if we return to the world of the Madaba map, with its considerably more elaborate representations of urban complexes, we can discern a common visual language for urban representation when we look at other roughly contemporary mosaics from the same region. Among the sixth-century mosaics from the Church of St. John at Gerasa are expert vignettes of cities such as Alexandria, with its jumble of buildings and two cupolas. The church on the acropolis at Ma'in has a remarkable series of city images from approximately a century later, hence already under the Umayyad caliphs. Inscriptions are in Greek and architectural representations are in the tradition of those at Madaba and Jerash. Nicopolis, in the southern sector of Palestine, is represented by a large building and one smaller one, whereas Areopolis in Transjordan seems to show several buildings, suggesting, quite correctly, a larger city. Esbous, not far from Areopolis, is dominated by a large dome. The smaller city of Gadoron resembles a large boarding house (Figure 1.12). It is impossible to correlate any of these buildings with distinctive features of the cities as we know them today. But then we hardly know these places. Several of them appear on the Madaba map with altogether different vignettes, but the lack of a stan-

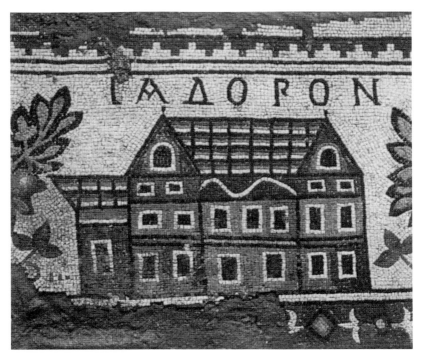

1.12. MOSAIC OF GADORON, CHURCH OF THE ACROPOLIS, MAʻIN.

dard icon for a city can, as we shall see, be interpreted in more than one way. For the present, let us observe that what is comparable in these various mosaics is the style, as well as the extraordinary interest in commemorating so many of the neighboring cities of the region.

The evocation of many cities, apart from being decorative, would have served to remind the citizens of a place that they were not alone. They were part of a larger Hellenic world that was, as maps could show, tied together by roads and the traffic that passed over them. This preoccupation with urban density gave an individual character, no matter how stylized, to each separate city, while situating all of them, at the same time,

in a global perspective. Although the Peutinger Table clearly had a road map as its base, it is not necessary to follow Avi-Yonah in postulating a comparable map for the Madaba mosaic. After all, the Peutinger Table shows the roads, whereas the Madaba mosaic does not. Yet for that part of Palestine preserved on the mosaic, it would be difficult to identify any city or village that was not within range of a road of some kind. What is striking, in fact, about the Madaba map is the wealth of information it provides on settlements that have no biblical resonance whatever. This is a record of the contemporary world.

For the vicinity of Jerusalem, distances in miles are given twice (the fourth and the ninth mile from the city). Although some have supposed these designations to be authentic site names, one would first require a parallel to such names before crediting them here. This is simply information about the region. Many exceptionally small places are included, such as Erouta or Ka[ph]erouta, which is normally identified with Kafr Rut.[20] The important Byzantine city of Elusa in the Negev, missing in Eusebius' *Onomasticon,* is given prominence at Madaba, and so is the sanctuary of Lot, now being excavated at the southern end of the Dead Sea. The fort of Moa, unknown to Eusebius, is signaled in the Araba depression. Beitmarseas, Characmoba, and Praesidium, all major sites of Byzantine Palestine, are conspicuously absent in the *Onomasticon,* but they are on prominent display in the Madaba map.

Particularly indicative of the independence of the mosaicist is the double siting of Mount Garazim and its sister mountain. The map displays the pair twice, in two distinct locations and with different spellings. Eusebius in the *Onomasticon* places the two mountains, which he calls Garizim and Gaibal (transparently the Semitic word for mountain) near Jericho, where the mosaicist has, in fact, depicted both of them. But he

20. Avi-Yonah, *Madaba Mosaic Map,* 1954, p. 60.

also includes them a second time in the vicinity of Neapolis, reflecting a tradition of the Samaritans, whom Eusebius had explicitly pronounced to be in error on the point *(sphallomenoi)*.[21] The map's inclusion of the Samaritan tradition is manifestly not indebted to Eusebius because it employs, in Greek transliteration, *Tour,* which is the Aramaic word *Tûr* ("mountain"), to introduce the names of both peaks near Neapolis: Tur Gobel and Tur Garizim.

A number of cities on the Madaba map are otherwise completely unknown. Such are Seana, Athribis, Thmouis, Kainoupolis (Figure 1.13)— places that presumably came into being long after Ptolemy's *Geography.* Whether they existed in the time of Eusebius is unclear, since there is no reason to think they would have attracted his notice as biblical places. Still other sites show a different perspective from that in Eusebius. Sychar and the Well of Jacob are different places on the map, but they are the same in Eusebius.

At Madaba, Galgala is equipped with its celebrated twelve stones from the Jordan River. The site is named *dodekalithon* ("twelve-stoned"), and the image clearly shows twelve stones. But Eusebius states unambiguously that the site lay to the east of Jericho, whereas the mosaicist has placed it to the northwest of the city. Avi-Yonah's attempt to reconcile this siting with the text of the *Onomasticon* cannot stand.[22] Furthermore, although the famous and venerable stones are mentioned in the *Onomasticon,* their number is not indicated there. The map is scrupulous in showing exactly twelve. There is clearly no indebtedness of one document to the other.

Gerara occurs in both Eusebius and the map (Figure 1.13), but only the map marks out the Gerariticus Saltus, which by its Latin terminology betokens the language of the Roman imperial administration. It

21. Eusebius, *Onomasticon,* 64.10 and 14.7.

22. Eusebius, *Onomasticon,* 66.4; and Avi-Yonah, *Madaba Mosaic Map,* 1954, p. 37.

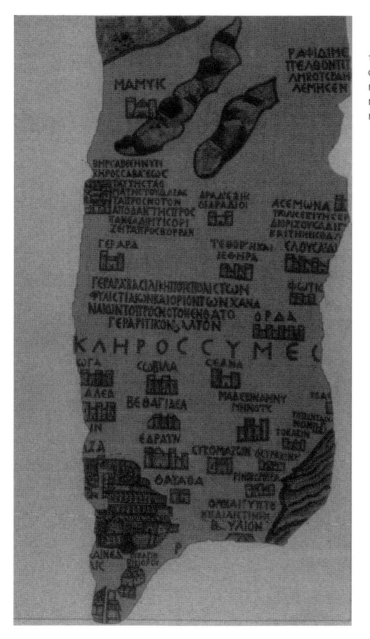

1.13. UNKNOWN CITIES WEST OF MAMPSIS IN THE NEGEV, MADABA MAP.

most likely designates an area that was (or had been) an imperial estate. This estate is actually attested in three literary texts: George of Cyprus, Theodoret, and Procopius of Gaza.[23] The map's reference to the royal city of the Philistines and the border of Canaanite territory does bear some relation to the *Onomasticon* entry—but direct influence is altogether unlikely, since the order of the items is reversed and the vocabulary is altered. The Madaba map also depicts a number of unnamed villages and forts in the vicinity that can only serve to show that the region in which they lay was not deserted. It goes without saying that these places are unknown to Eusebius' biblical gazetteer.

Once liberated from the constraints of Eusebius and his task of biblical exegesis, we can see that the Madaba map, like the other mosaic documents of late antiquity, reflects the contemporary world. This understandably included a lively interest in biblical themes, but they were by no means the principal interest. That was the inhabited landscape itself, its population and cities, its geography and topography. This world, on the present showing of the fragment we possess of the Madaba map, extended into Egypt, and there is no reason why it should not have extended equally to the north and west of Syria. It would be hard to accept that Antioch did not appear on this panorama of the Near East, just as Alexandria was certainly there. And if these two great cities, why not Constantinople as well? Smyrna and Ephesus would not have been far behind in their claims.

What survives for our contemplation at Madaba is the self-representation of the Christian Near East in the sixth century, a self-representation in which cities saw themselves in relation to other cities, just as another mosaic at Madaba projected itself in relation to Roma and Gregoria. In passing we have noticed that many of the mosaics of cities find their place near or alongside mythological scenes. It now becomes pertinent

23. See Avi-Yonah, *Madaba Mosaic Map,* 1954, p. 72.

to ask whether the myths as shown played a similar or different role in each of the many cities. We must ask whether myths served, just as buildings and architecture appear to have done, as a means of individuating cities within a shared culture. Did myths achieve a comparable objective of pulling together the teeming societies of the widely dispersed cities of the early Byzantine Near East?

2

Myths

In the town of Madaba the excavated domestic space underneath the Church of the Virgin is known as the Room of Hippolytus, since its central panel is devoted to the doomed passion of Phaedra for her stepson Hippolytus. As we have seen, the tableau is enlivened by cupids at play. At the top of the frame personifications of three cities—Madaba itself, Rome, and Gregoria—supervise the whole business. In her extensive review of Jordanian mosaics in the broader context of production in the Near East, Janine Balty limited herself to underlining the importance of this pavement as a sign of the permanence of classical culture in the sixth century. But she chose to emphasize the exceptional character of this work: "On the strictly iconographic level, the mosaic of the Room of Hippolytus remains an exception. Mythological representations had perhaps become rare at the time. All the same, one might ask whether the almost exclusively religious nature of the monuments excavated so far (churches, convents, chapels . . .) does not falsify our vision somewhat."[1] The magnificent mosaic from Sarrin that Mme. Balty has herself

1. J. Balty, *Mosaïques antiques*, 1995, p. 130.

published now provides an arresting corrective to her earlier perspective, and it adds to an already growing number of impressive mythological dossiers in urban domestic contexts.[2]

Material on myth always needs to be integrated into a society's historical context, its religion, and its culture.[3] Garth Fowden has rightly observed, "The Madaba Hippolytus mosaic evokes—and presupposes knowledge of—a whole mythological world."[4] The rhetorical, descriptive, and poetic literature of late antiquity all contribute substantially to the testimony of the mosaic pavements. Libanius and Choricius both abound in classical allusions that vividly illustrate, from the pagan and the Christian side respectively, the vigor of myths in the daily life of the Near East. In particular, another writer, Procopius of Gaza, furnishes in his *Ekphrasis eikonos* a detailed description of mythological figures he saw on display at Gaza. These included Theseus, Ariadne, Hippolytus, and Phaedra. The epic of Nonnos, recounting in the fifth century the career of the god Dionysus in elaborate hexameters, and the salon verses of Dioscorus of Aphrodito in the sixth century both exhibit a virtuosity in pagan mythology that would have been the envy of the mythographer Apollodorus. And we should not forget that Dioscorus was undoubtedly a Christian and Nonnos may well have been.[5]

Farther afield, in domestic art, recent discoveries of small sculptures on pagan themes (such as Europa and the Bull) at Aphrodisias, as well as the paintings in the so-called Hanghäuser (hillside dwellings) at Ephesus, eloquently attest to the persistence and popularity of the old

2. J. Balty, *La Mosaïque de Sarrîn*, 1990. The mosaic depicts Artemis, Dionysus, Meleager, Aphrodite, Heracles, and Europa.

3. Muth, *Erleben von Raum*, 1998, usefully discusses the contextual issues; see especially "Erforschung der Mythenbilder," on pp. 27–47, with reference to domestic mosaics in North Africa and Spain.

4. Fowden and Fowden, *Studies on Hellenism, Christianity and the Umayyads*, 2004, p. 97.

5. See Friedländer, *Spätantiker Gemäldezyklus in Gaza*, 1939; Chuvin, *Mythologie et géographie dionysiaques*, 1991; MacCoull, *Dioscorus of Aphrodito*, 1988.

stories in a Christian world.[6] No less revealing are the pagan images found hidden in the wells of private houses in sixth-century Athens during some moment of ecclesiastical restraint, or the wealth of divine images that emerged during a Christian pogrom in Alexandria at roughly the same period.[7] The stories and their protagonists had a longevity that far outlasted Constantine's official Christianization of the empire.

Although these stories generally seem to have a standard form and iconography, among the mosaics of the late antique Near East at least one pagan myth acquired an unusual variant form that suggests a local reworking of a traditional account could sometimes occur. We owe to Jean-Charles Balty a thorough analysis of mosaic images of Cassiopeia at Palmyra, Apamea, and New Paphos.[8] In these examples, a plainly deviant tradition of her celebrated rivalry with the Nereids is proudly proclaimed. In traditional versions the Nereids, outraged by Cassiopeia's claim to a greater beauty than theirs, succeeded in winning Poseidon's help in punishing the boastful lady, whose daughter Andromeda was subjected to terrible perils as a result. But in these eastern mosaic images Cassiopeia appears crowned as the victor in the beauty contest (Figure 2.1). The crowning of Cassiopeia, contrary to the standard story, looks like a local adjustment to the story by Lebanese residents near Mount Casios. They were promoting their eponymous heroine. This revisionism appears to have taken hold more broadly in the region.

But such an aberrant representation of standard myth is by no means common. To be sure, a myth could sometimes lose its mythic potency,

6. Smith and Ratté, "Aphrodisias"; Scherrer, *Ephesos*, 1995, pp. 102–115, 200–202. For the Hanghäuser, see www.oeaw.ac.at/antike/ephesos/hh/einstieg.html. For a Western context but with Aphrodisian workmanship, see Bergmann, *Chiragan, Aphrodisias, Konstantinopel*, 1999.

7. Frantz, *The Athenian Agora, Vol. 24*, 1988, pp. 87–88; Zacharias, "Life of Severus," *Patrolog. Orient.* 10 (1907), p. 34.

8. J.-C. Balty, "Une Version orientale méconnue du mythe de Cassiopée," 1981, pp. 95–106.

2.1. CROWNING OF CASSIOPEIA, NEW PAPHOS, CYPRUS.

as seems to have happened with the legend of Romulus and Remus after the Roman legions left the East. The twins appear with the wolf in a sixth-century hospital mosaic in Syria without the slightest allusion to Roman power (Figure 2.2).[9] They simply illustrate succoring the needy. And oc-

9. Bowersock, "The Rich Harvest of Near Eastern Mosaics," 1998, 693–699, especially p. 696; reprinted in *Selected Papers*, pp. 149–158, especially p. 154.

MYTHS

casionally a mythological image could be arrogated by a family as a kind of escutcheon. For example, the house of an Asbolius at Sepphoris put on display a mosaic of a centaur to remind visitors of the eponymous centaur Asbolos (Figure 2.3).[10] But the rampant mythological revisionism that had prevailed in literary works of mythography seems not to have been extended generally into the visual realm. There is little that is comparable to the kind of invention that Alan Cameron has fully documented for ancient mythography.[11] Dares of Phrygia, Dictys of Crete, Philo of Byblos, and (to take an extreme instance) Ptolemaeus Chennus have no parallels in art, and by late antiquity most of the stories, as they appear in images, look much more like a binding artifact of Near Eastern culture than a differentiating one. Even the centaur of the Asbolii presupposed a common knowledge of the tradition of centaurs.

The discoveries in Jordan and Palestine in recent decades have, as we have already seen, called attention to the distinctive topography and urbanism of the whole territory through clearly labeled and symbolized features on the ground, such as mountains, roads, shrines, and architecture. But the mythological mosaics, particularly the rich finds at Madaba, tend to reinforce the situation that was discussed at length in a memorable colloquium held in Paris in 1983 under the title *Iconographie classique et identités régionales*.[12] Classical iconography in mythological mosaics shows few indications of regional identity, and even such a variant as the Cassiopeia victory is conspicuously not regionally confined but widely diffused (at least from Palmyra to Cyprus).

10. Bowersock, "The Mosaic Inscription in the Nile Festival Building at Sepphoris," 2004, pp. 764–766, correcting and reinterpreting Di Segni, "Greek Inscriptions," 2002. Independently and similarly on almost all points: Feissel in *Bulletin Epigraphique*, 2004, p. 391. Di Segni, "The Mosaic Inscription," 2005, ignores the correlation between Asbolius and Asbolos and much else besides.

11. Cameron, *Greek Mythography*, 2004.

12. The proceedings were published in *Bulletin de Correspondance Hellénique*, suppl. 14, 1986.

2.2. HOSPITAL MOSAIC WITH ROMULUS AND REMUS, MUSEUM AT MA'ARAT AN-NUMAN.

Fawzi Zayadine has discussed a remarkable painted image from a tomb at Capitolias (Beit Ras): a representation of Prometheus and a human being he has created (identified as simply *plasma*). Prometheus as creator of mankind seems to have had special resonance in the Near East. The Capitolias fresco has a close parallel at Philippopolis (Shahba), to the northeast, as well as in an extraordinary mosaic, recently published, from Edessa in Mesopotamia (Figure 2.4)[13] Here, in the center of Syriac Christianity, is a representation of Prometheus at work in the creation of mankind through the inspiration of a personified Psyche ("soul"), and in an upper register this whole process of a pagan genesis is observed by a committee of divinities—Zeus, Hera, and Athena. The figures are identified in Syriac estrangela letters. Edessa was a Christian

13. Zayadine, "Peintures murales," 1986. On the new Edessa mosaic, see J. Balty and Briquel Chatonnet, "Nouvelles Mosaïques inscrites d'Osrhoène," 2000, pp. 31–72 with fig. 1; and Bowersock, "Notes on the New Edessene Mosaic," 2001/2002, pp. 411–416.

MYTHS

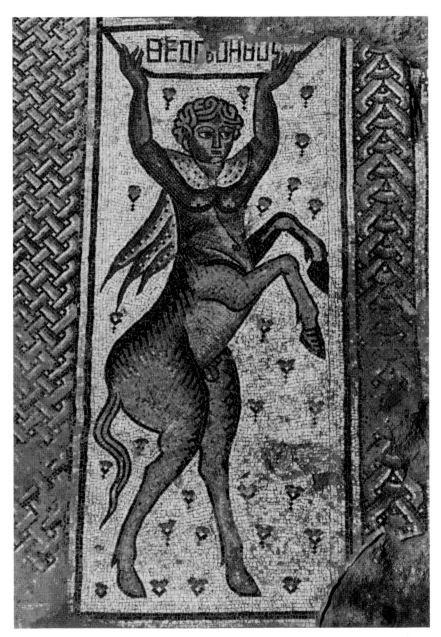

2.3. MOSAIC OF CENTAUR FROM THE NILE FESTIVAL BUILDING AT SEPPHORIS.

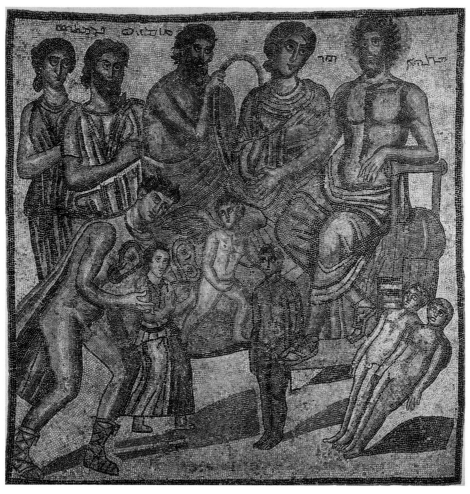

2.4. MOSAIC OF PROMETHEUS FROM EDESSA.

city at the time this mosaic was made, and it is more than likely that this mosaic came from a Christian dwelling of some kind.

The recurrence of other mythical figures in the surviving repertoire of art and literature from the region reinforces the impression of traditional themes in full vigor and cultivated by adherents of all faiths. The most

prevalent of these mythic figures were undoubtedly Heracles and Diony-
sus. Their careers from infancy, including first bath and early education,
and onward to world travel and heroic epiphanies, are thoroughly docu-
mented on mosaics as well as other objects, especially sarcophagi. In lit-
erature the post-Alexander tradition of the young and riotous Dionysus
survives in the precious forty-eight books of Nonnos' epic *Dionysiaca*.
Fragments of later Greek verse provide glimpses of similar treatments of
Heracles.

Among the most impressive discoveries of recent years is a large mo-
saic at Sepphoris that actually brings these two gods into direct confron-
tation (Figure 2.5). They sit grandly, facing each other, in the central
panel. They are clearly engaged in a serious drinking competition—a
traditional and popular episode, familiar from a mosaic discovered at
Antioch. Around the sides of the Sepphoris mosaic we have, among
other things, the first bath of the infant Dionysus, a jubilant procession,
and the vomiting of a drunken Heracles, all shown in naturalistic detail
(Figure 2.6). This mosaic fills a central salon of a luxurious villa at
Sepphoris, a town that is well known to have been largely populated by
Jews. A resident so affluent as to have owned the villa with the mosaic of
Heracles and Dionysus was undoubtedly a Jew, and Zeev Weiss has ar-
gued that this Jew was none other than the Jewish patriarch, who is
known to have lived in Sepphoris.[14]

The first bath of Dionysus in the villa at Sepphoris may be compared
with another image of the god in a six-panel mosaic at a villa in New
Paphos on Cyprus. In the upper-right panel the god as an infant is
proudly settled in the lap of Hermes (Figure 2.8). Below, in another
panel, Apollo can be seen with his lyre (Figure 2.9) as he contemplates

14. Talgam and Weiss, *Mosaics*, pp. 127–131. For the depiction of the drinking contest
between Dionysus and Heracles in a mosaic at Antioch (Figure 2.7), see Kondoleon,
Antioch 2000, pp. 170–171, no. 55.

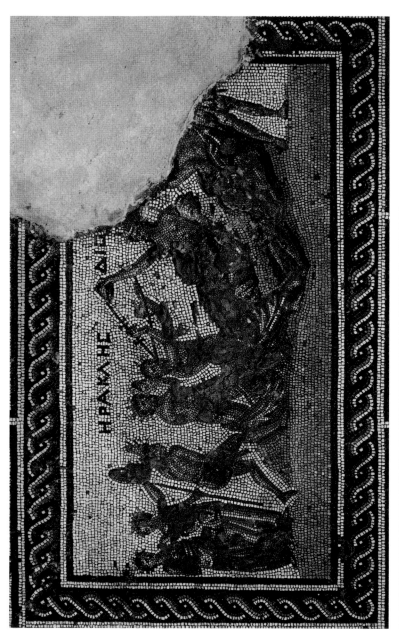

2.5. DRINKING BOUT OF HERACLES AND DIONYSUS, HOUSE OF THE PATRIARCH (?), SEPPHORIS.

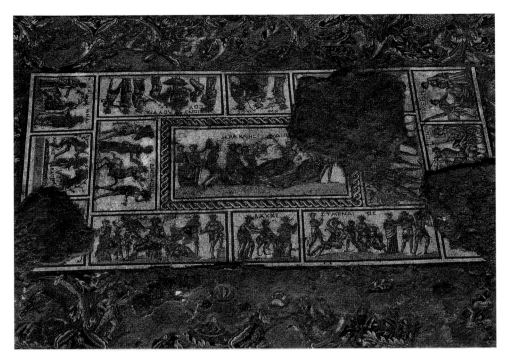

2.6 MOSAIC OF DIONYSUS AND HERACLES WITH SURROUNDING PANELS, SEPPHORIS.

his competitor Marsyas being skinned alive. Proclus and other Neoplatonists reveal that Apollo's lyre symbolized the harmony of the world, and his appearance in a mosaic floor among panels devoted to the career of Dionysus seems to be a reflection of a philosophical interpretation of a popular myth. The scene of Hermes holding the child god bears an uncanny resemblance to Christian mother-and-child imagery, as has often been noticed, and so this Dionysiac tableau takes on the function of conveying a soteriological motif, with which Apollo's lyre would fit perfectly.[15]

15. Bowersock, *Hellenism*, 1990, p. 50 with plate 2.

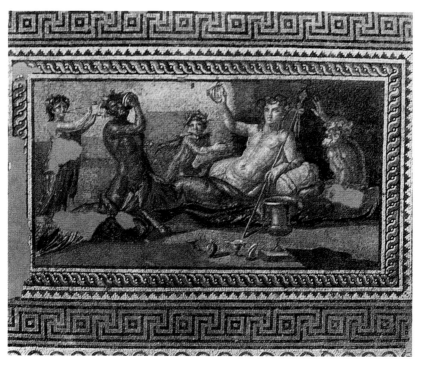

2.7. DRINKING BOUT OF HERACLES AND DIONYSUS, ANTIOCH.

The music of pipes often surrounded Dionysus, nowhere more conspicuously than in the Ariadne episode unforgettably shown on an Egyptian textile now at the Abegg Stiftung in Switzerland (Figure 2.10).[16] Here the ultimate piper, Pan, is included in the god's entourage, contributing, as he often did, to the din of a Dionysiac procession (Figure 2.11). The universality of Dionysus, exemplified by his appearances in a variety of mythic contexts, underlies his memorable appearance in the mosaic from Sarrin in Syria (Figure 2.12; published by Janine Balty),[17] where he keeps company with other popular mythological figures, including

16. Bowersock, *Hellenism*, 1990, pp. 52–53 with plates 10–11.
17. J. Balty, *La mosaïque de Sarrîn*, 1990.

2.8. HERMES HOLDING THE BABY DIONYSUS, NEW PAPHOS, CYPRUS.

Heracles once again, this time in pursuit of Auge and Europa, whose abduction by Zeus in the form of a bull was another fashionable motif, as the small sculptures from the sculptor's workshop at Aphrodisias would suggest. The ancient Greek novelist Achilles Tatius led off his entire work *The Adventures of Leucippe and Cleitophon* with a description of a painting of Europa on the bull.

The Sarrin mosaic evidently combines, in a fashion not altogether clear, both symbolic cities and mythological motifs, although we cannot say whether the city we see there was originally assigned a specific identification. Yet such a union of cartographic iconography with mythological representation provides the background for a famous image in the floor of the nave of the Church of the Apostles at Madaba (*in* the floor, it must be emphasized, not under it). There Thalassa, the sea, offers her bene-

diction to all and personifies, without the slightest offense to Christian sensibilities, the surrounding Mediterranean that defined the western frontier of the region to which Madaba and her fellow cities belonged (Figure 2.13). For myth embraced all of these cities.

In Madaba in particular the mosaicists produced several pieces so innovative in form, if not in subject, that they were defaced by the outraged Christians who first happened upon them in modern times. They were

2.10. DIONYSUS AND ARIADNE, TEXTILE, ABEGG FOUNDATION.

torn out from their contexts and mutilated, leading Janine Balty recently to complain that the absence of context, both architectural and archaeological, leaves their precise date still open. They have no parallel anywhere, either in the region or in the empire. But no one doubts that they belong somewhere between the later fifth century and the end of the sixth. Not surprisingly we have a Heracles, with his club and animal skin, explicitly identified by the Greek letters ΕΡΑ, for ΕΡΑ[ΚΛΗΣ]. And again not surprisingly there is a Dionysiac scene with a Bacchant and satyr, a scene that was considerably more intact upon discovery than it is

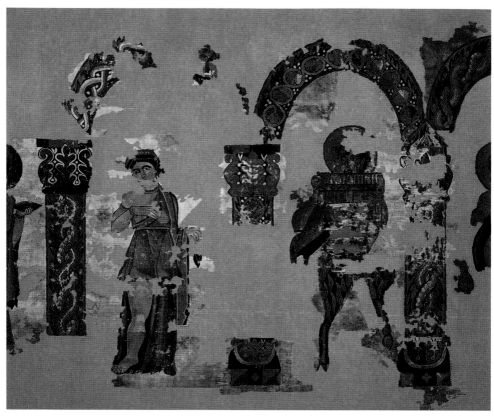

2.11. PAN AND NURSE, TEXTILE, ABEGG FOUNDATION.

today. We know that Ariadne had been identified in the panel when it was first seen. The apparent indecency of the representation seems to have provoked the pious of modern times into mutilating this image. The explicit depiction of male genitalia on the surviving male figure, now clearly paralleled by the Heracles at Sarrin, was presumably only one instance among many. This exceptional iconography in the corpus of Near Eastern mythological mosaics cannot be avoided. Dionysus and his votaries were often represented, although not always in this explicit way. The

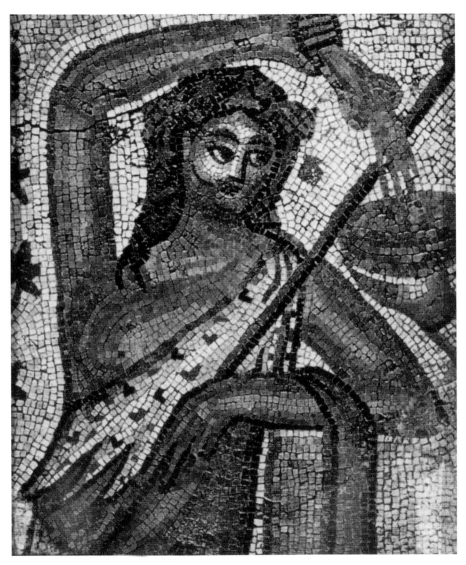

2.12. MOSAIC OF DIONYSUS, SARRIN.

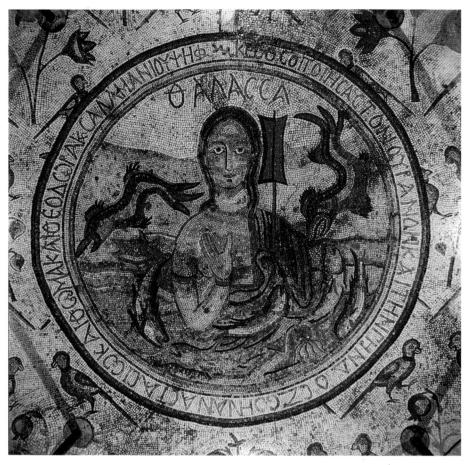

2.13. MOSAIC OF THALASSA (THE SEA), CHURCH OF THE APOSTLES, MADABA.

problem arises in a much more acute form in another Madaba mosaic. It concerns the story of Achilles.

Here we find Achilles and Patroclus, with flaring cloaks attached over their shoulders, standing in full frontal nudity (Figure 2.14). Their names are written over them, but it is important to observe that the name of Patroclus appears in the nominative (ΠΑΤΡΟΚΛΟΣ) while that of Achilles is in the accusative (ΑΧΙΛΛΕΑ). Achilles is playing the lyre, which

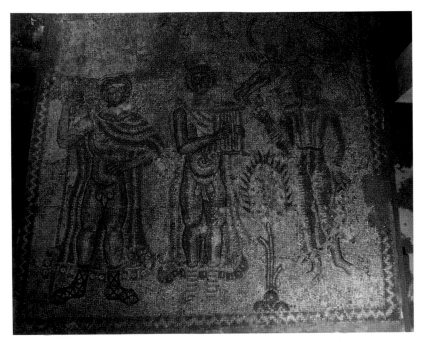

2.14. MOSAIC OF ACHILLES AND PATROCLUS, MADABA.

recalls the harmonious music of Apollo in the villa on Cyprus. In late antiquity the lyre became a popular attribute of Achilles. It took up the pacifying motif of Apollo's lyre, since Achilles played it when he repudiated war. Here in the scene with Patroclus on the mosaic at Madaba, the lyre recalls the ninth book of the *Iliad,* in which emissaries from Agamemnon find the angry hero playing by the edge of the sea in the company of Patroclus.[18] In the mosaic scene a woman can be seen dancing in a di-

18. A newly published mosaic from Osrhoene shows a very different rendition of this episode from Mesopotamia. Achilles (with his lyre) and Patroclus, both luxuriously garbed, are seated on a sofa. The figures are identified by name in Syriac. See J. Balty and Briquel Chatonnet, "Nouvelles Mosaïques inscrites d'Osrhoène," 2000, pp. 31–72, with the Achilles mosaic reproduced in color as fig. 8 opposite p. 61. The suggested date is early Severan, and it clearly comes from another world—both geographically and chronologically.

aphanous dress, just beyond a small tree. Beside her is what has been taken to be a name, ΕΥΒΡΕ. Providing the only surviving testimony to the work's upper register (now lost), the photograph reproduced here, made soon after the mosaic's discovery, proves that there was more music from a Pan playing on his pipes and a whirling figure with castanets.

All this means that an important part of the scene on this mosaic included Dionysiac elements. The dancing woman in the revealing dress may perhaps be one of them. She is normally taken to be Briseis, Achilles' concubine, but it requires monumental faith and little scholarship to accept that ΕΥΒΡΕ is any kind of Greek for Briseis. The beta would have been sounded in this period as a *v,* and the diphthong ΕΥ would also have been heard with a *v (ev).* It seems to me that we have here an iteration of the V-sound in a word that begins with the syllable *ev-,* although it is unclear whether we have a sequence of ΕΥΡ or ΕΒΡ. Christopher Jones has suggested that with the different inflections of the names of Patroclus and Achilles, the mosaic may be giving the observer a statement. If that is the case, then we may propose Πάτροκλος Ἀχιλλέα εὗρε ("Patroclus has found Achilles"). It is apparent that the word is not continued farther to the right, unless of course there were letters on the other side of the dancing woman.

The story of Achilles was among the most frequently represented in late antiquity after the careers of Heracles and Dionysus. Numerous studies have documented the iconography of the late-antique Achilles.[19] His first bath, a subject that appears only in late antiquity, became nearly

19. Cf. Delvoye, "La Légende d'Achille," 1984, pp. 184–199. The popularity of Achilles has deep roots in the Roman imperial period, as can be seen from his importance in Philostratus' *Heroicus.* Statius' unfinished epic, the *Achilleid,* was designed to tell the whole story of Achilles' life. On the Bosporan cult of Achilles, see Hommel, *Der Gott Achilleus,* 1980. A newly published inscription from Kerch (ancient Panticapaeum) compares the teacher of the young king Sauromates I with Achilles' teacher, the centaur Cheiron; see Vinogradov and Shestakov, "Laudatio Funebris," 2005.

MYTHS

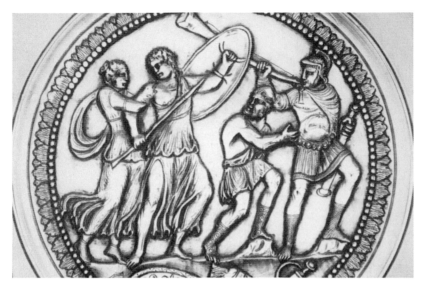

2.15. CENTRAL MEDALLION, AUGST SILVER PLATTER, SWITZERLAND.

as prominent as that of Dionysus. His sojourn as a transvestite on Skyros seems to have been particularly popular. A famous representation on a silver dish from Augst—formerly Kaiseraugst—in Switzerland (Figure 2.15) has recently found a striking parallel in the so-called Sevso Treasure (Figure 2.16).[20] Furthermore, the story of the hero's concealment as a woman among women seems to have been a feature of late-antique mimes, to judge from citations of it in the *Apology* that Choricius of Gaza composed in defense of the performances of mimes. One can

20. See the Sotheby's catalogue issued when the Sevso Treasure was last on public view, in New York: Marlia Mango, *The Sevso Treasure*, February 1990, p. 9. Note also "a superb series of ivory plaques with a life-cycle of Achilles (A.D. 360s) discovered in Eleutherna (Crete) in 2002 by P. Themelis": Athanassiadi, "Ascent to Heroic or Divine Status," 2004, p. 212. For a discussion of Achilles on Skyros and the popularity of Achilles' life-cycle, see now Muth, *Erleben von Raum*, 1998, pp. 151–185; and Leader-Newby, *Silver and Society*, 2004, pp. 125–137.

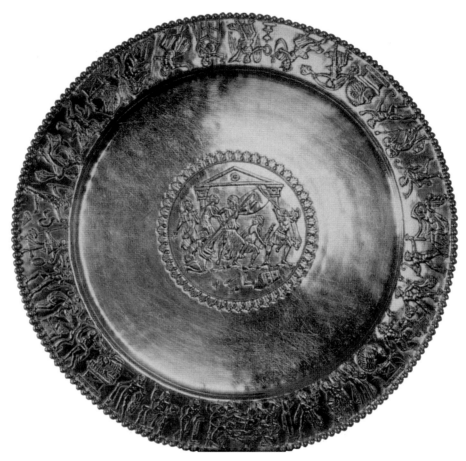

2.16. ACHILLES, SILVER PLATTER, SEVSO TREASURE.

readily imagine the dramatic potential of cross-dressing. Choricius was careful to insist that this activity in no way impugned the masculinity of a hero.

The scene on the Madaba mosaic finds its closest parallel in a series of episodes on a bronze *situla*, or bucket, in the palace of the Doria Pamphili at Rome. Here Achilles is discovered with his lyre in the company of Patroclus. Subsequent scenes appear to show a woman in a veil

MYTHS

being led away at the behest of Agamemnon. She ultimately appears before Achilles, who is again playing his lyre.[21] These panels would suggest an interpretation of the woman on the Madaba mosaic as the same figure we see on the *situla,* and that figure is normally assumed to be none other than Briseis. But both Homer and the mimetic tradition make plain that Achilles was tempted to return to war by offers of many women for his pleasure, and it might be more prudent to look at the *situla* in the light of the Madaba images rather than the reverse. The Madaba scene clearly puts Achilles into a Dionysian context. The upper register guarantees this. The dancing pose of the woman in the lower register would be more consonant with a Bacchant than with Briseis. The lyre of Achilles appears to provide the musical accompaniment for the dancer, and the inscription, if read as a statement, informs us that Patroclus is entering upon a scene of revelry. This would not be unconnected with the efforts to persuade Achilles back into battle, but it would represent frames from the story that have hitherto been obscure.

The independent Madaba panel with Bacchant and satyr (and Ariadne, now lost) likewise shows a dancing woman and an exposed male (Figure 1.2). The style and iconography are clearly related to those of the Achilles mosaic, as well as the Heracles at Sarrin. With the exception of Mme. Balty, no one has tried to explain these highly original images. She recognized their uniqueness and suggested that fecundity may have been implied. It seems likely that these representations may actually help us to explain the whole phenomenon of shared and recurring mythological motifs. Most, of course, are more decorous than those two from Madaba, but they all serve to undermine the once attractive view proposed by Kurt Weitzmann: that book illustrations lay behind mosaic scenes (as they were known to him—there are far more now).[22] Mosaics

21. See Delvoye, "La Légende d'Achille," 1984.

22. See, for example, the papers from a 1973 symposium in honor of Weitzmann: *The Place of Book Illumination in Byzantine Art,* 1975.

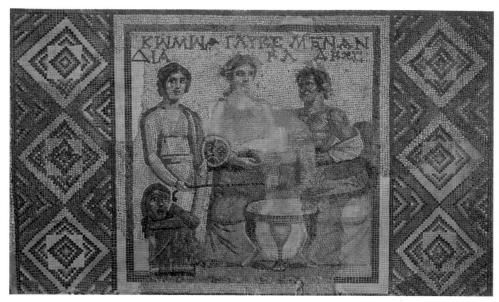

2.17. PERSONIFICATION OF COMEDY (LEFT), WITH THE AUTHOR MENANDER (RIGHT) AND HIS MISTRESS GLYCERA, ANTIOCH.

had been a fruitful means of commemorating theatrical pieces in the past. The mosaics with characters from Menander's comedies are good examples of this (Figure 2.17).[23] We have already noticed that the exceptional popularity of certain episodes such as that of Achilles on Skyros apparently points to the mimes.

It is worth asking now whether we may be seeing in the mythological mosaics generally some kind of reflection of the immensely popular mime theater of late antiquity. Entertainment of this kind frequently exploited myth and represented gods or legendary figures. Performances took two principal forms in late antiquity. In one there was a single dancer, called a *pantomime*, who silently enacted all roles in the story

23. Cf. a famous example from Antioch in Kondoleon, *Antioch*, 2000, p. 156, no. 40.

through the use of masks and whose gyrations were commemorated on inscriptions as "tragic rhythmic movement."[24] By contrast, an actor called a *mimos* ("mime") was one of a troupe of performers, both male and female, who spoke the lines of a scripted text and did not use masks. But both pantomime and mime worked to the accompaniment of music and chorus, and the mimes sometimes even danced.[25] These forms of popular entertainment had a long pedigree, of course, as Lucian's essay on dancers makes plain. The emperor Lucius Verus had been particularly enamored of this kind of theater. Even in Lucian's day, pagan moralists such as Aelius Aristides had denounced the lubricious character of the performances of pantomime dancers, just as Christian preachers, such as John Chrystostom, were to do in late antiquity.[26] But people went to them anyway and reveled in them. Even Jacob of Sarug—who fulminated against the spectacles in the early sixth century—lets slip, in reproaching his flock, the vital information that Christians not only watched the spectacles but performed in them.[27]

The themes most beloved of the mosaicists are precisely the themes of the mimes and pantomimes. Libanius registered them in loving detail in his famous reply to Aristides, the speech he wrote in support of dancers. Heracles, Dionysus, Achilles, Europa—they are all there. So is Phaedra, whose story is vividly depicted in the Madaba mosaic unearthed beneath the Church of the Virgin. As Libanius says, in reviewing

24. Robert, "Pantomimen," 1930, pp. 106–122, reprinted in *Opera Minora Selecta*, I:654–670. For a recent example, published by a scholar in ignorance of Robert's fundamental treatment, see Blümel, "Epigramm auf einen Sieger in Eurhythmie," 2004, pp. 20–22. What the inscriptions call "$\epsilon\mathring{\upsilon}\rho\upsilon\theta\mu\acute{\iota}\alpha$" provoked Tatian (*Oratio ad Graecos,* 22) to express his displeasure with "$\tau\hat{\wp}\ \nu\epsilon\acute{\upsilon}o\nu\tau\iota\ \kappa\alpha\grave{\iota}\ \kappa\iota\nuo\upsilon\mu\acute{\epsilon}\nu\wp\ \pi\alpha\rho\grave{\alpha}\ \phi\acute{\upsilon}\sigma\iota\nu,$" "someone who bobs about and writhes in an unnatural way."

25. Robert, "ΑΡΧΑΙΟΛΟΓΟΣ," 1936, 235–254, reprinted in *Opera Minora Selecta*, I:671–690.

26. Theocharidis, *Beiträge zur Geschichte des byzantinischen Profantheaters,* 1940.

27. Moss, "Jacob of Serugh's Homilies on the Spectacles," 1935, 87–112.

the mythological subjects of the dancers, "A dancer creates Phaedra in love, and adds as well Hippolytus, a self-controlled young man."[28] That describes the role-changing of a single pantomime. But if all the characters are to be represented at one time, we could equally be in the presence of a mime performance—without masks.

This story is widely represented in art in different mediums, as it obviously was on the stage. The celebrated *situla* in the Doria Pamphili collection and now both the ewer and two large *situlae* in the Sevso Treasure are devoted to the Phaedra story.[29] A well-known mosaic from Sheikh Zwed, southwest of Gaza, furnishes a particularly good parallel with the Madaba representation of the Phaedra story (Figure 2.18).[30] The top panel shows the disconsolate lady herself seated in her residence, while outside stand her nurse and Hippolytus with his huntsmen. It should come as no surprise, after our discussion of Dionysus and Heracles, to find that the lower panel of this mosaic is devoted precisely to those two gods.

Procopius' word-painting or *ekphrasis* ("description") of a cycle of paintings at Gaza similarly evokes images of both Hippolytus and Phaedra, depicted, as Paul Friedländer demonstrated, largely but not wholly in conformity with the recognizable and repeated iconography known from wall paintings and sarcophagi.[31] They show the nurse in a conspiratorial role with Phaedra and often a group of puzzled servants standing near her. Here is Procopius' description: "Leaning over, she is conversing as if

28. Libanius, *Orationes*, 64.67.

29. For antecedent representations of the story in the Roman imperial age, see the many sarcophagi discussed in Zanker and Ewald, *Mit Mythen leben*, 2004, pp. 325–330. On the Sevso silver see Mango, *The Sevso Treasure*, February 1990, p. 10.

30. See the recent publication with illustration in Merkelbach and Stauber, *Steinepigramme*, 2002, no. 22/77/01, pp. 450–453.

31. See Friedländer, *Spätantiker Gemäldezyklus in Gaza*, 1939; also H. Buschhausen, "L'Eglise Sainte-Marie, la salle d'Hippolyte et l'*Ekphrasis* de Procope de Gaza," in Piccirillo, *Mosaïques byzantines*, 1989, pp. 161–177.

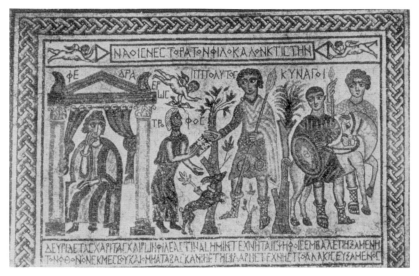

2.18. PHAEDRA AND HIPPOLYTUS, SHEIKH ZWED.

talking in secret. . . . She bends forward, placing her left hand on her hip in order not to fall over (as her age would incline her to do). Of her body only her face and hand can be seen, and indeed the hand peeks out from the clothing over the lower half of her arm. . . . Let us look at the servants [θεραπαίνας] beside her. . . . One puts her face to another's, and their cheeks are touching. They seem to be whispering." At Madaba and at Sheikh Zwed, the nurse is already involved in bringing Hippolytus to her mistress.

In the Madaba mosaic Phaedra is seen with her servants at a moment of immense drama and energy. A servant of Hippolytus is brutally beating the nurse, who has brought the unwanted message of love. This scene finds its echo in another of Procopius' images, in which the beating is depicted. The decisive element is a falconer, described by Procopius as a humane protector of the poor old woman. He is said to hold a falcon high on one hand, and to have a receding hairline. This is

how he appears at Madaba. The figure of the falconer there is a perfect match. But until the appearance of the Madaba mosaic the scene in Procopius had been unparalleled in either text or illustration.

Procopius has therefore introduced into the better-known scenes from the Phaedra story a new iconographic element that provides a link between the well-documented representations and the unusual scene of theatrical violence as depicted at Madaba. The orator at Gaza and the mosaicist at Madaba had seen something that is, on present showing, unique to the Near Eastern region, and this new iconography, like the crowning of Cassiopeia, is likely to have had its origins in local tastes.

The playful and decorative panel of Erotes placed just above the scene of Phaedra and Hippolytus at Madaba conserves an important part of local imaging of the scene. It matches very closely the opening lines of Procopius' *Ekphrasis:* "Erotes are at play alongside their mother Aphrodite, and from her they flutter over to Adonis." Procopius explicitly connects this scene with Phaedra, although the arrows that he claimed the Erotes aimed at her at Gaza are absent in Madaba. Yet the conjunction of Aphrodite, Adonis, and fluttering Erotes with the Phaedra episode must be again connected with the images described by Procopius.

The attention paid to the Phaedra story in Malalas' *Chronographia* shows a clear attempt to cleanse an impure or unedifying narration of a popular story for the benefit of Christian consumers of pagan myths.[32] Phaedra did not suffer from a guilty passion for Hippolytus, according to Malalas: it was all a terrible mistake. In a similar vein, Malalas had endeavored to turn Dionysus into a mortal with a human genealogy and to assert that he had a known burial place. He wanted to deny the divine origin of the god from Semele's thigh, and thereby to make him palatable to Christians. But in amending the stories of Phaedra and Dionysus, he

32. Malalas, *Chronographia* (Bonn), 88–89.
33. Choricius, *Orationes,* 21 (=12), 1, p. 248 (Foerster-Richtsteig).

exposed by denials what was generally believed about the myths in the sixth century.

Choricius of Gaza, another Christian writing in the sixth century, twice combines Achilles and Hippolytus in evocations of pagan myths that his hearers would readily know. In both instances he is discussing the dramatic mimesis of these characters and can therefore only be alluding to performances of the mimes. "You who look at the chorus of dancers in the theater of Dionysus have seen a certain performer when he danced the role of Achilles or the youth born of an Amazon (Hippolytus) or some other man, and you have also seen him splendidly imitating the beloved Briseis or the lovesick Phaedra and thereby trying to persuade the theater not that he is not miming but rather that what he is miming is wholly natural."[33] It is no accident that in this period the *mimos,* or *pantomimos* (as appears to be the case in this passage), was also known as a *biologos,* someone who "tells a life."[34]

Choricius returned again to these examples when he discussed the means by which a performer defined his character in the theater—by distinctive clothes or a distinctive setting or a distinctive mannerism. He observes that even if the performer acting Phaedra left much to be desired, she could nonetheless be identified by the stage-set for the dancing and by the others around her, such as the nurse and Hippolytus himself. Likewise, says Choricius, for Achilles, the son of Peleus.[35]

If we look to the mimes as an explanation of the high degree of unifor-

34. See Robert, "Pantomimen," 1930.

35. For testimony to the reputation of a mime/βιολόγος, see the splendid epigram from Patara in praise of a performer who is called "the mouth of the Muses, the flower of praises of Hellas." His work is paraphrased as "λέγων βιότου τὰ γραφέντα": Merkelbach and Stauber, *Steinepigramme,* 2002, no. 17/09/01, pp. 37–38. In general see Choricius, *Orationes,* 32 (=8), where he defends the profession of the *biologoi:* "ὑπὲρ τῶν ἐν Διονύσου τὸν βίον εἰκονιζόντων." For Choricius' account of themes performed in the mimes, see now Malineau, "L'*Apologie* de Chorikios," 2005.

mity of theme in Near Eastern mosaics, we can perhaps also find a context for the innovation in representation and, in particular, in those unparalleled representations of standard themes at Madaba. These could be understood to show what was seen in the mimes, where, as in the old Folies Bergères, clothes only served to accentuate the unclothed or could be readily seen through. Flaring cloaks, similar to those worn by Patroclus and Achilles, were a standard accessory for pantomimes, and we know that the range of covering for mimes, who did not use masks, could extend to the minimum—namely, total nudity.[36] Furthermore, Tatian, addressing the pagan Greeks, proves that masks were not always worn even by a pantomime, since he mocks the facial makeup on an admired performer.[37] It was alleged that the emperor Elagabal demanded that there be no simulated sex on stage, only the real thing.[38]

The new mosaics in the so-called Nile Festival Building at Sepphoris reveal Amazons, each with a breast exposed, in a lively choreography that the excavator has called dancing (Figure 2.19).[39] It looks as if this too is a representation of a mime, and the exposed breast—simulated or in fact—would not be an unreasonable part of the costuming. In fact, the women appear to be bidding farewell to one of their number. If this is really what is happening, we may have here the story of Penthesilea departing for the battle in which Achilles killed her. The Amazons at Troy were part of the repertoire of mime; and if Penthesilea was no Phaedra in

36. In the public spectacle described at the end of Book 10 of Apuleius' *Metamorphoses* (*The Golden Ass*) there is a naked youth with a cloak over his left shoulder (10, 30: "adest luculentus puer nudus, nisi quod ephebica chlamida sinistrum tegebat umerum"), exactly as Achilles and Patroclus are depicted on the Madaba mosaic.

37. Tatian, *Oratio ad Graecos*, 22 ("διὰ πηλίνης ὄψεως"). In the same passage Tatian describes the daughters and sons of spectators watching performers engage in sexual activity, presumably simulated, on stage.

38. *Historia Augusta*, Elagabalus, 25, 4: "in mimicis adulteriis ea, quae solent simulato fieri, effici ad verum iussit."

39. Weiss and Talgam, "The Nile Festival Building and Its Mosaics," 2002, pp. 55–90.

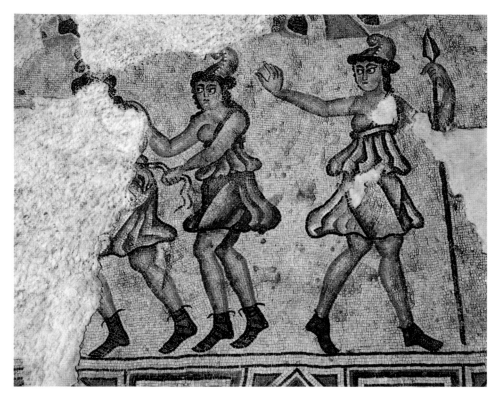

2.19. AMAZONS, NILE FESTIVAL BUILDING, SEPPHORIS.

popularity, her story nevertheless fascinated so deep a Neoplatonist as Proclus. The Amazons at Sepphoris are another arresting illustration of a universalizing pagan mythology that so thoroughly Jewish a city absorbed with ease.

The unifying power of the mimes and their mythological stories provoked the wrath of Jacob of Sarug and others, but his mellifluous Syriac verses tell us what pleasure these entertainments gave ordinary citizens. "Do you agree to cherish gods who love adultery?" he asks. "Is your ear willing to have the report of the house of Zeus the adulterer fall upon it? Is it good for you to see the depravity of female idols? Can you endure,

being the servant of Jesus, to take delight in Apollo? Do you believe the mimings concerning the hero Heracles?" And the response he imagines his enraptured listener offering to him in justification is this: "The dancing of that place cheers me up. . . . I do not go to believe. I go to laugh. And what do I lose if I laugh and do not believe?"[40]

This is the laughter and the cheer of the mosaics we see today. The response of the Christian patron of the mimes, as imagined by Jacob of Serug, is precisely the justification offered by the Christian apologist Choricius. A recent attempt by T. D. Barnes to deny that Choricius was a Christian seems to me to depend fatally on an indefensible argument.[41] Because the orator avoids mentioning Christian attitudes, writes of Zeus as the creator of the world, and describes the Islands of the Blest, Barnes asserts: "What Choricius reveals, perhaps inadvertently, of his deepest assumptions about life and death surely stamps him as a pagan." By this criterion Dioscorus of Aphrodito, certified beyond dispute as a Christian writer, had to have been a pagan, and the whole debate over the confession of Nonnos need never have taken place.

But Barnes's opinion is also weakened by the perfect parallel that Choricius provides with Jacob's Christian enthusiast. The eminent orator of Gaza took up the objection, echoed in Jacob, that watching adultery on the stage was naturally corrupting. But he went on to argue: "Since the whole affair is a kind of playfulness, its objective is song and laughter. Everything is contrived for spiritual refreshment and relaxation. It seems to me that Dionysus, who is, after all, a laughter-loving god [φιλογέλως γὰρ ὁ θεός], has taken pity on our nature. Different cares disquiet different people—the loss of children, grieving over parents, the death of siblings, the demise of a good woman. Poverty gnaws at many, and dishonor brings grief to many others. It seems to me that Dionysus

40. Moss, "Jacob of Serugh's Homilies on the Spectacles," 1935, 87–112.
41. Barnes, "Christians and the Theater," 1996, pp. 161–180.

takes pity on mankind and provides an opportunity for diversion in order to console those who are dispirited. . . . The god is generous and well disposed to humanity, so as to provoke laughter of every kind."[42]

The centrality of Dionysus in Choricius' apology for the mimes is unmistakable. It fits perfectly with the Dionysian frame for the mosaic of Patroclus and Achilles at Madaba, to say nothing of the illustration of the Bacchant and satyr. Dionysus is the encompassing, enabling inspiration for the mimes and, through them, for the mosaicists who evoked the entertainments of their cities. Madaba affords a glimpse into the collective culture of leisure and relaxation, a culture that coruscates—at Sarrin, at Sepphoris, at Palmyra, at New Paphos—with a tantalizing radiance. If the mosaics teach us that the cities were proudly conscious of their own individuality, they also demonstrate a shared enjoyment of the ancient and undying tradition of ancient myths. These myths did not constitute a burden inherited from the past or a guilt that had to be expiated. They created the large cultural community that the Madaba map spreads before our eyes.

42. Choricius, *Orationes*, 332 (=8), 31–32.

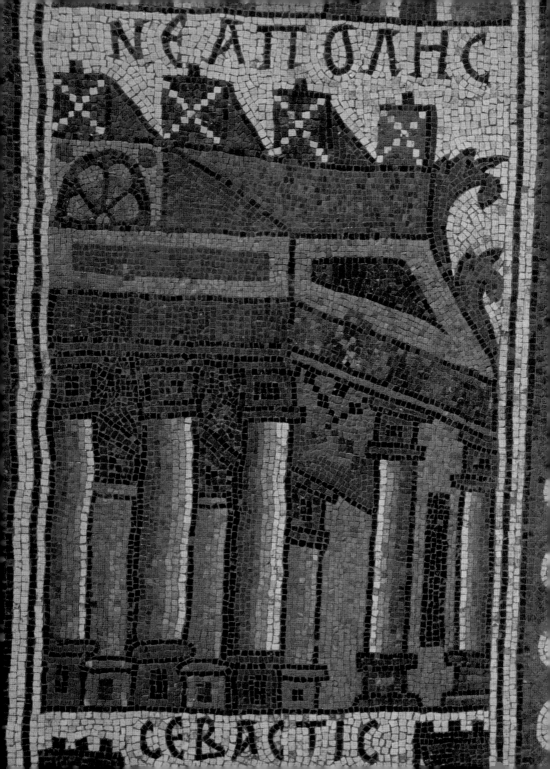

3

Cities

The late-antique world of Palestine, Syria, and Arabia (Transjordan) was one of civic individualism and communal culture. Each city was its own distinctive place, and continued to be—as the Ma'in mosaics, for example, have already implied. Although myths and mimes could provide shared experiences throughout the region, the cities constituted a fabric of great diversity. The Madaba map and the mosaics at Ma'in and Jerash display a certain awareness of the place of any one city in that larger fabric. But no one was quite ready for the ultimate revelation of this phenomenon that came with the excavation of the Church of St. Stephen at Umm er-Rasas in Jordan.[1] A grand mosaic complex bears a dated inscription and, along its border, an elaborate sequence of images of cities. The whole is spectacular, all the more so because the inscription is dated to the eighth century. The tesserae recording the date are visibly disturbed and so the present date of 785 may have originally been 718,[2] but with either date we are confronting a mosaic document of tech-

1. Piccirillo with Alliata, *Umm al-Rasas, Mayfa'ah*, 1994. See also Ognibene, *La chiesa di Santo Stefano ad Umm al-Rasas*, 2002.

2. Schick, "Christianity in the Patriarchate of Jerusalem," 1991.

nical brilliance and detail that was indisputably created in the Muslim period. The continuity implied at Ma'in by mosaics of different centuries is demonstrated even more powerfully here.

In the known city vignettes, from the Madaba map onward, it is impossible to distinguish a consistent or recurring iconography for individual cities. It is, of course, possible that the representation of the cities was generally stylized with no attempt to signal famous topographic features. Yet it happens that precisely where we are aware of such features, the vignettes were clearly designed to show at least some of them. This is indisputably the case for Jerusalem and for Galgala on the Madaba map. For Umm er-Rasas itself we are able to control the representation as well, since two substantial images of the city survive and can be compared with the site as it exists today. Both images identify the place as Kastron Mefaa. This allows us at long last to identify Umm er-Rasas as the location of the city of Mefaa named both in the *Onomasticon* of Eusebius and in the *Notitia Dignitatum,*[3] and known as Mefa'a in Arabic texts.

The first of the two newly discovered depictions of the city on mosaic comes from the Church of the Lions in the later sixth century, and the second from the eighth-century mosaic in the Church of St. Stephen (Figures 3.1 and 3.2). Thus, long after the Umayyad caliph at Damascus, Abd al-Malik, had eliminated Greek from the Muslim bureaucracy, the name continued to exist in Greek. Even in the eighth century it takes its place with the Greek names of many of the neighboring cities illustrated in the same pavement. In fact, this late mosaic corresponds in other respects to its ancestors in the region. It displays witty Erotes and cheerful boatmen, even if their message was unfortunately obscured afterward by zealous iconoclasts of a persuasion still to be determined.

The image of Mefaa from the sixth century shows two clearly sepa-

3. *Notitia Dignitatum,* p. 81, 19 (Seeck). Eusebius, *Onomasticon,* 128, 21.

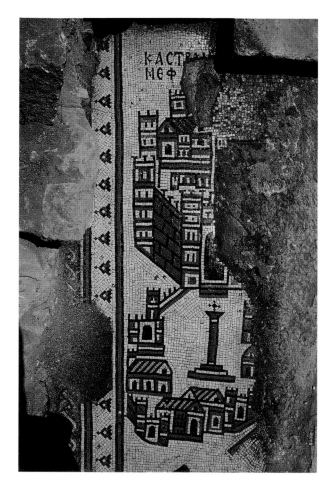

3.1. MOSAIC VIGNETTE OF
KASTRON MEFAA IN THE
CHURCH OF THE LIONS, UMM
ER-RASAS, WITH CROSS ON
THE COLUMN.

rate parts of the city, one a walled castrum and the other an external set-
tlement, lacking a continuous surrounding wall but connected to the
castrum. Between the two parts stands a column on three steps with a
cross on its top. The eighth-century image shows exactly the same urban
plan, with minor variations—notably the absence of a cross atop the col-
umn. A comparison of these images with the site that Father Piccirillo

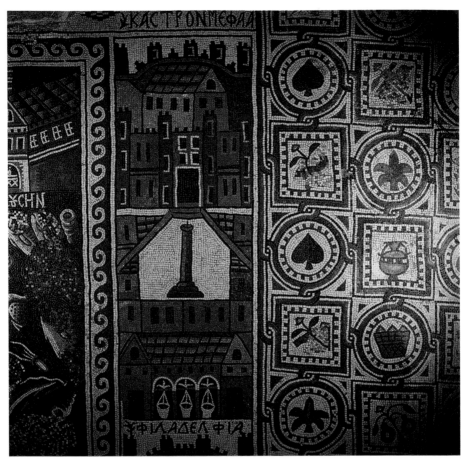

ΥΚΑCΤΡΟΝΜΕΦΑΑ

ΥCHN

ΥΦΙΛΑΔΕΛΦΙΑ

3.2. MOSAIC VIGNETTE OF KASTRON MEFAA FROM THE EIGHTH CENTURY, CHURCH OF ST. STEPHEN, WITHOUT CROSS.

has actually excavated leaves no doubt that this is not a merely symbolic representation of Mefaa, but an attempt to show the real city (Figure 3.3). At its southern end stands a walled castrum beyond which, to the north, is a sprawling settlement closely aligned with it. The column, as it appears on the two mosaics, no longer survives. Originally, as Noel Duval has proposed, it perhaps supported a statue of an emperor, which

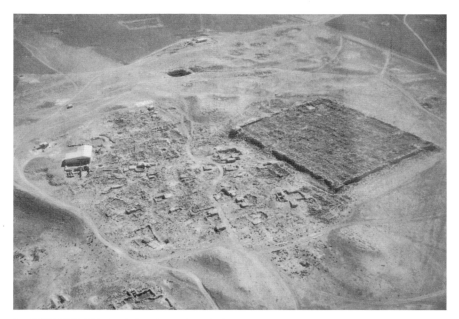

3.3. EXCAVATED SITE OF MEFAA, UMM ER-RASAS.

was later replaced with a cross. This single free-standing object was obviously a significant feature of the city's identity. Accordingly, we may reasonably attach some importance to a comparable object that stands on the site of the city today (Figure 3.4). Although this is manifestly not the column shown on the mosaic, it serves as a distant descendant by echoing the ancient emblem of Mefaa. Just as ancient names survive in later names, meaningful ancient monuments can be reincarnated in later ones. The Church of the Holy Sepulchre, constructed on the site of Christ's tomb at Jerusalem, is, for example, just such a building.

The parade of cities represented at the Church of St. Stephen in Umm er-Rasas includes many of the highlights on the Madaba map (Figures 1.6 and 3.5). Its images are architecturally detailed and carefully contrived, but where they illustrate cities known from the Madaba, Jerash, or Ma'in pavements, there is no similarity in iconography or design. Yet

3.4. MODERN TOWER AT UMM ER-RASAS.

where we are able, as at Umm er-Rasas itself, to bring some knowledge of the site to the vignettes that we see, we might expect to find explicit reference to existing buildings or monuments, even if there is no single common iconography throughout the region to make that reference.

Let us attempt to read the mosaic and its parade of cities. It is not my intention to offer an analysis of these images from the perspective of art history, since I would not be competent to do so and Noël Duval has already provided a full account of the architectural conventions employed in representing the cities.[4] But the mosaic is just as much a historical document as an artistic one. In the abundance of its urban images, in its selection of cities depicted, and in its late date, it has much to tell about

4. See Duval in Piccirillo with Alliata, *Umm al-Rasas, Mayfa'ah,* 1994, as well as in Piccirillo with Alliata, *The Madaba Map Centenary,* 1999.

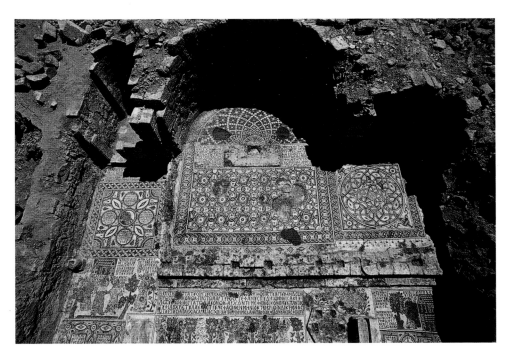

3.5. UPPER PART OF THE CITY MOSAIC AT THE CHURCH OF ST. STEPHEN, UMM ER-RASAS.

the survival of Greek self-consciousness, or rather the cultural continuity from the sixth century to the eighth across a region that passed from the jurisdiction of Byzantium to that of Damascus.

The pavement introduces itself through an elaborate inscription at the top, as well as several more at the sides. The principal text records the completion of the mosaic by John son of Isaac to honor the protomartyr Stephen. A date of October in the year 680 of the Province of Arabia is correlated with a dating in the second year of a fifteen-year "indiction" cycle. One is immediately struck by the preservation of the dating formula of the Roman province, which had been founded in 106. Over many centuries the province had suffered alterations, and it had eventually been subsumed into the empire of the Umayyads. The provincial year 680,

which translates into 785, unfortunately cannot be combined with the indication of a second indiction, but, as Robert Schick has pointed out, the tesserae are disturbed precisely where the number appears.[5] This may well represent the date of a repair to a work with an original date of 718 earlier in the same century. The extant tesserae would be consistent with this hypothesis. In any case, the mosaic belongs to the eighth century. The iconoclastic damage, to which we shall revert later, would imply original construction before the spread of iconoclasm earlier in the century.

The adjacent inscriptions record the benefactors of the church, and in two panels there are additional city vignettes beyond those in the main border. Although these have normally been discussed along with the other vignettes, it is misleading to do so, because there is an obvious correlation of benefactors and their villages. That is why these two vignettes do not show cities of the magnitude and importance of the others. They should not be interpreted together with them but should be seen instead as illustrations of cooperative support from the surrounding towns for the new church. Both places, Diblaton and Limbon, are relatively insignificant.

The first, as has been recognized by Father Piccirillo, is the same as the Almon Diblataim in the biblical Book of Numbers and the Bet Diblataim in Jeremiah. No secure identification with a modern toponym is possible. But what needs to be stressed here is that the two citations in the Bible clearly put the site near Mount Nebo and thus not very far from Umm er-Rasas.

The other place associated with benefactors, Limbon, has been identified with the village of Libb, ten kilometers south of Madaba. Although Piccirillo noticed that Josephus had included a Lemba among the fourteen Transjordanian cities occupied by Alexander Jannaeus,[6] he thought that the normal editorial correction of this name to Livias was now

5. Schick, "Christianity in the Patriarchate of Jerusalem," 1991.
6. Josephus, *Antiquitates Judaicae*, 13.397.

proved wrong by his mosaic at Umm er-Rasas. In fact the opposite is the case. Lemba in the text of Josephus simply represents the later, nasalized pronunciation of Livias and would have been an easy error for any scribe. In the eighth century, Limbon, pronounced "Limvon," is far more likely to be Livias, which just happens to be situated at the foot of Mount Nebo. The connection with Nebo is confirmed by the inscription naming the benefactor who is commemorated in the Limbon panel: it reads, "Lord, remember your servant Qaiyum, the first [or elder] monk at Pisga [μοναχοῦ πρου (with ligature) Φισγα]." The ligature conceals either πρώτου or πρεσβυτέρου. This is presumably the abbot at Pisga, which is well known as another biblical name for Nebo. Accordingly we discover from the two panels that both places named with the church's benefactors belonged to the same region of Mount Nebo. This in turn tells us about the links of Mefaa with the adjacent territory. The two vignettes have a quite different message from those in the mosaic's border.

When we turn our attention to the border, we see immediately that it was created by someone who knew the geography of the region. On the left side facing the apse is a succession of major cities, all of which lie to the west of the Jordan River. They begin with the holy city of Jerusalem at the top, in the place of honor and identified only as the holy city, *hagia polis*—much as it is in Arabic today, *al-quds* (Figure 3.6). Then follow Neapolis, Samaria Sebaste, Caesarea, Diospolis (Lod), Eleutheropolis (Betogabri, Beit Guvrin), Ascalon, and Gaza. The sequence of the cities is clearly not fortuitous. From Jerusalem the designer's eye moves northwest to the coast at Caesarea and then turns south into the coastal plain to reach the sea at Ascalon and Gaza, the gateway to Egypt.

The border on the other side includes only cities to the east of the River Jordan. Here pride of place is naturally assigned to Mefaa itself, at the top, in a comparable position to that of Jerusalem and taking even more space vertically than the holy city. Below Mefaa, the distribution of

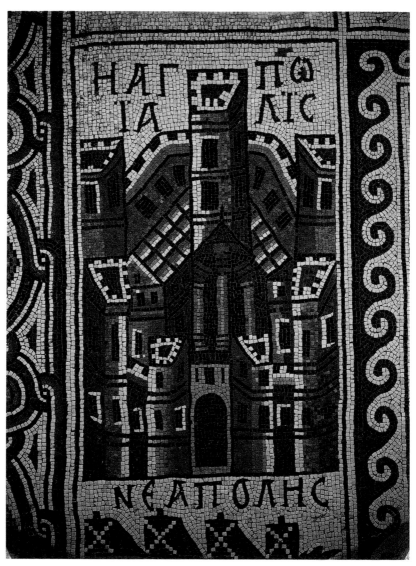

3.6. THE HOLY CITY (HAGIA POLIS): JERUSALEM IN THE MOSAIC AT THE CHURCH OF
ST. STEPHEN, UMM ER-RASAS.

places is just as well informed as it was in the left border. The designer's eye first goes north to Philadelphia (Amman), as the greatest city of the region, and it then travels southward to Madaba, the next-greatest city. Following after that are two smaller towns in the immediate vicinity, namely Heshbon and Belemount (the biblical Baʿal Maʿon). From the Madaba area the designer's gaze travels south to Areopolis (Rabba), and finally still farther south to Characmoba (Kerak), as seen in Figure 3.7. The only surprise here is Belemount, but the *Onomasticon* of Eusebius reveals that this village had become a large and important settlement in late antiquity. It is clear that for Mefaa, cities north of Philadelphia (such as Gerasa) and south of Characmoba (such as Petra) were not con-sidered part of the general region. This limited scope for the cities of Transjordan contrasts strikingly with the broad sweep of cities on the other side of the Jordan, extending as far as Caesarea on the coast to the north and Gaza on the coast to the south. We might reasonably say that the designer's gaze looked westward more than to the interior. It looked to the sea, on to Egypt, and presumably to the greater world beyond. Something similar seems to be happening in the Madaba map, and this tendency would encourage belief in the reports of Smyrna and Constanti-nople on the map at the time of its discovery.

There can be little doubt that the border arrangement of cities proves that whoever designed the mosaic had a sound knowledge of regional geography. The most reasonable explanation for such knowledge is the existence of one or more maps. Such a source would be more plausible for a visual document of this kind than dependence on a written text. We have already seen that the postulate of a written text as the source of the Madaba map collapses upon close inspection.

Accordingly this border of cities, decorative as It is, is not purely deco-rative. It reflects knowledge and thought. One might, therefore, expect comparable care in the images themselves. And that, I believe, is what we find, at least in those cases that we can control. To start with the city

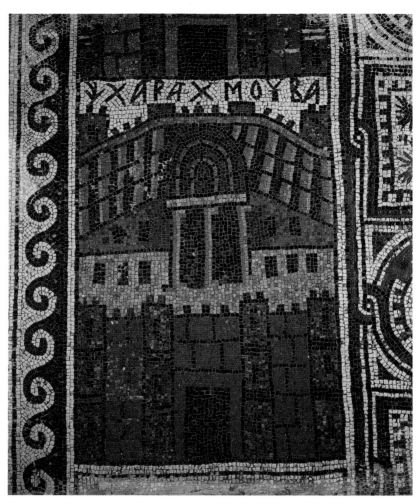

3.7. CHARACMOBA (KERAK), IN THE MOSAIC OF THE CHURCH OF ST. STEPHEN, UMM ER-RASAS.

of Mefaa itself, images separated by two centuries can, as we have already seen, be directly assessed by the topography of the site on the ground. At this point it is worth adding that the castrum and outer city are not the only features that match the extant remains. Even the two churches that lie in the mosaics within the castrum and nestle up against its wall appear to be the very buildings excavated in the matching location at Umm er-Rasas.

A similar conjunction with the real city exists for the image of the holy city, as indeed it did for the same site on the Madaba map. The Church of the Anastasis (the Holy Sepulchre) is unmistakable on the Umm er-Rasas mosaic, even though there is nothing like the topographic detail of the huge Madaba vignette. More impressive still is the representation of Neapolis (Nablus) by means of a magnificent columnar façade that looks more like a temple than a church (Figure 3.8). We know that upon one of the peaks of Mount Garizim stood a famous old temple of Zeus Hypsistos. It was accessible by a long flight of steps and was, with its columns, the most conspicuous of several shrines on the mountain. It was a symbol of the city, as Neapolis' coins in the Roman period show, and it would seem the obvious identification for the Umm er-Rasas image. Although the Church of the Theotokos on the same mountain has been suggested for this image, the classical design and the numismatic parallel point to the temple. What cannot be in doubt is that we obviously have here a precise topographic reference, not a stylized or conventional representation.

These are the most compelling cases for exact allusion to extant buildings in the images in the outer border. They suggest a lively interest in the neighboring cities, a kind of union of Hellenized centers inside the Umayyad world. The cities shown here contrast strikingly with the Egyptian cities in the interior border. These appear interlaced with figures and boats in what is clearly a stylized Nilotic scene (Figure 3.9). It is perfectly obvious that the cities represented there do not reflect any specialized

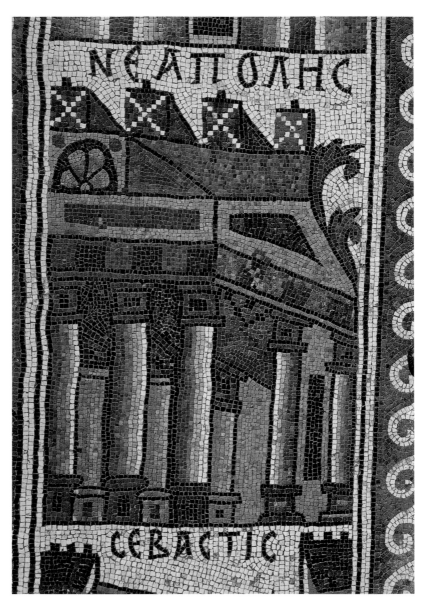

3.8. NEAPOLIS (NABLUS), ON THE MOSAIC OF THE CHURCH OF ST. STEPHEN, UMM ER-RASAS.

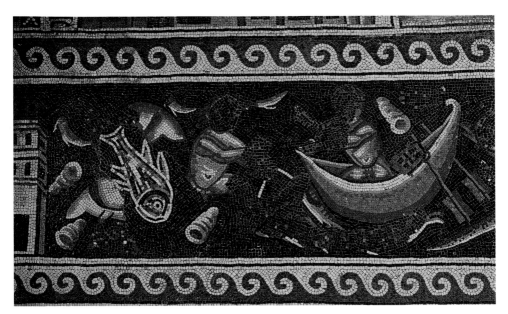

3.9. NILOTIC SCENES FROM THE MOSAIC OF THE CHURCH OF ST. STEPHEN, UMM ER-RASAS.

knowledge of the places beyond their names. One proof of this is that Alexandria and Heracleopolis have virtually identical buildings. The interior border calls to mind the traditional connections of Palestine with Egypt. The cities it names remind one of the Madaba map. Some are common to both, such as Kasion, Pelusium, and Kynopolis. Others are obscure, such as Panaou and Pseudostomon. Similarly obscure local names appear on the Madaba map as well. The designers at Umm er-Rasas have arranged their Egyptian cities in no clear order. In all respects it seems apparent that the Nilotic border serves a quite different function from the two great outer borders.

In his chapter for Father Piccirillo's recent full publication of the St. Stephen complex at Umm er-Rasas, Noël Duval has suggested that apart from Jerusalem, Neapolis, and Mefaa (Umm er-Rasas) the other cities

are all represented by purely symbolic vignettes. They have, in his opinion, no relation to reality, and the "proof" of this he believes to be the absence of common elements when the same cities are represented in Madaba or Ma'in (or both). But this proof presupposes that reality can be conveyed only by identical vignettes. The Jerusalem images at Madaba and Umm er-Rasas demonstrate beyond any doubt that real monuments can be represented in quite different settings and in different ways. If that is the case, then there is no reason to assume that real monuments are not represented in the vignettes for cities about which we know little or nothing architecturally. The important conclusion to be drawn from Duval's meticulous account of the Umm er-Rasas panels is not that most are unrealistic, but rather that there was no standard iconography for the cities. This point already seemed clear from the Madaba, Jerash, and Ma'in mosaics, but it is resoundingly confirmed by the material at Umm er-Rasas. The cities recur in the pavements over several centuries, and (where we can judge) their distinctive features are proclaimed. But the design is fresh every time. Once again, Weitzmann's notion that manuscript illuminations provided models appears untenable. Once again, just as with the myths, there is impressive repetition of theme but not of design.

The phenomenon that we observe in the images created for the churches at Jerash, Ma'in, and Umm er-Rasas belongs above all to a time of transition: although rooted in the Greek art of the East, it had already become part of Umayyad culture. Therefore it is hardly surprising that a comparable phenomenon can be observed in the images of another monument of the same period, the Great Mosque in Damascus. According to the geographers Al-Muqaddasi and Yakut, the walls of the porticoes of the mosque were decorated with mosaics representing the cities and villages of the whole world.[7] We obviously have here a kind of

7. See the discussion and bibliography in Rabbat, *The Citadel of Cairo,* 1995.

map covering a region familiar to those who entered this sacred space—something similar to the Madaba map and the geographic borders at Umm er-Rasas. The cities were individuated visually so that visitors could distinguish one from another. The vignettes naturally lacked complete verisimilitude, but they provided representations in a visual language that evoked each city and was easy to read. Furthermore, it is worth recalling here that representation of this kind never wholly disappeared from Islamic art in the subsequent centuries. As Nasser Rabbat has well demonstrated in his fine book on the royal architecture of the Mamluks, the mosaics with city vignettes that were made in Damascus and Cairo at the end of the thirteenth century were entirely parallel with those of the Umayyad period.

Stepping back now to see the St. Stephen mosaic as a whole, we should recall the Madaba map, which is our earliest mosaic evidence for the city tradition. This document is, for us at least, the beginning of a tradition that we can now see continuing after some three centuries. This reminder of the map at Madaba leads us directly to another document in the same town: the mosaic in the Room of Hippolytus, with its personifications of three cities observing the ill-starred Phaedra and Hippolytus (Figure 1.3). The insouciant conjunction of Rome, Gregoria, and Madaba on the model of the three great cities of the empire takes its place in the continuing assertion of local identity within a larger framework of region and empire. The three *tychai* sit majestically overlooking a traditional assortment of cheerfully mythological figures and a scene of Phaedra's passion (Figure 3.10). Each holds a kind of crosier that extends the standard iconography of *tychai* with a spear by installing a cross at the top of the *hasta*. Rome and Gregoria are favored with earrings, whereas the proud home city, though associated with them, lacks this jewelry. Each of the three ladies holds a container. Rome has a cornucopia of fruit that Piccirillo takes to be pomegranates and pears. Madaba also has a cornucopia, with two sheaves of wheat protruding from it. By contrast,

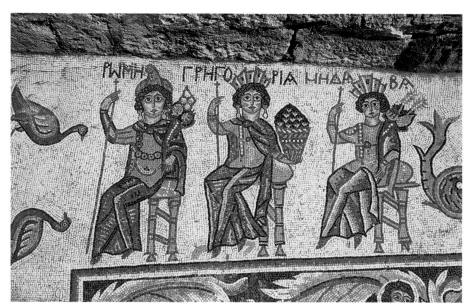

3.10. THE PERSONIFIED CITIES *(TYCHAI)* OF ROME, GREGORIA, AND MADABA IN THE MOSAIC FROM THE ROOM OF HIPPOLYTUS, MADABA.

Gregoria holds a basket of flowers. The headdress for both Gregoria and Madaba is the turreted city, but Rome has a helmet or cap. Gregoria is privileged by her basket, Rome by her headdress, and these two appear superior to Madaba by virtue of their earrings. As a young art historian, Mary Margaret Fulghum, acutely pointed out to me, there is also a careful gradation of size in the three figures as we read from left to right. There is a complicated hierarchy on display here.

The three cities have the general manner of the three personifications on the Peutinger Table: Rome, Constantinople (with the odd cap or helmet), and Antioch (perched on a river) (Figures 1.9–1.11). The personified *tychai* of cities apparently made another appearance at Umm er-Rasas in the Church of Wa'il, although regrettably some iconoclast zealots have deprived us of much of their image (Figure 3.11). But only recently another triad of cities has turned up in a surprising place: on a

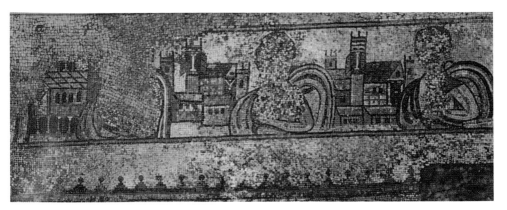

3.11. MOSAIC WITH DEFACED CITIES *(TYCHAI)* FROM THE CHURCH OF WA'IL, UMM ER-RASAS.

3.12. GRAFFITO OF *TYCHAI* ON A WALL AT APHRODISIAS IN CARIA.

graffito in late-antique Aphrodisias in Asia Minor (Figure 3.12). It is hard to make out the images amid the other graffiti, but three throned figures with crown and orb are, with effort, discernible and unmistakable. The usefulness of the Aphrodisias graffito lies in its proof of a broadly understood visual language for a trio of great cities of the empire.

The argument for reading "Gregoria" as "Constantinople" turns upon a tenth-century text, the Patria of Constantinople, which has been attributed falsely to Kodinos. There, in a list of buildings put up in the city, we are told that two ladies, called Alexandria and Gregoria, went from Rome in the time of the first Theodosius, and that each built a monastery for women that took their respective names. From this slender testimony it has been assumed that the monasteries may have given their name to a district of the city, even though no text actually names such a district. Janin had postulated that it might have existed, and, as often happens, a speculation has been cited as if it were a fact.[8] We are thus invited to imagine that Madaba for some reason seized upon the name of the part of the city containing the Gregoria monastery to designate the whole of Constantinople. It might be imagined that the normal name would have taken too much space,[9] although mosaicists have never been hesitant to divide up words or employ ligatures. Quite apart from the issue of women's monasteries in Constantinople at the supposed date, the whole argument collapses upon inspection of the text of pseudo-Kodinos. The monasteries were dedicated to Saint Dominica (Saint Kyriakê in Greek). This saint did not exist before the tenth century, and the texts and holy

8. Pseud.-Kodinos in Theodor Preger, *Scriptores originum Constantinopolitanarum* (Teubner reprint, 1989), p. 275, line 18, to p. 276, line 2. Cf. Janin, *Constantinople byzantine*, 1964, p. 354 ("le quartier aurait pris son nom").

9. Cf. J. Balty, *Mosaïques antiques*, 1995, p. 132, on *tychai* types for the Madaba city images; and idem, in Piccirillo, *Mosaïques byzantines* 1989, p. 155, with n. 32 on p. 159. On pp. 174–175 of that volume, H. Buschhausen has a long discussion of Gregoria, ending up in despair with Constantinople. Like many others, he assumes that Rome is old Rome.

days for her all postdate that time. The account of Alexandria and Gregoria is transparently part of the creation of what Gilbert Dagron has so aptly called "Constantinople imaginaire."[10]

There is therefore no reason to identify the central figure as Constantinople. Nor would it plausible to find that great city on a Near Eastern mosaic in a smaller size than the old western capital. We are, after all, in the later sixth century in this mosaic. The real question ought rather to be, "Why is Rome here at all?" By this date the dominant place it once had, as in the prototype of the Peutinger map, had disappeared. If one looks again and more closely at the headpiece of Rome in the Madaba trio, it is significant that it is utterly different from the city crowns of the other figures. It is, as we have noted, either some kind of helmet or possibly a Phrygian cap—exactly what Constantinople is wearing in the Peutinger Table. Madaba's Rome ought therefore to be the new Rome, the second Rome, Constantinople itself. The arrogation of this name had begun in the fourth century, on present evidence with Themistius.[11] As time passed and circumstances changed, the newness of the title and the secondary position both evaporated, and the city became known simply as Constantinople or Rome.[12]

Accordingly, in Gregoria we should see Antioch. Alexandria generally took fourth place anyhow, and from the perspective of Syria and Palestine (what was to be the Arabs' *bilâd al-shâm*) Antioch was part of the neighborhood enclosed by Thalassa, who provided the vantage point of Madaba's map. The Orontes River does not appear as a figure at

10. Dagron, *Constantinople imaginaire*, 1984.

11. Themistius, 182 A. Cf. Gregory of Nyssa in *Anthologia Palatina*, 1.5: "νεοθηλέα Ῥώμην."

12. As early as Theodosius II, ca. 425, Constantinople is simply called "Rome" without any qualification: see Feissel, "Le Philadelphion de Constantinople," 2003, pp. 495–521. The habit became more and more common, as in, e.g., *Anthologia Palatina*, 15.47 and 16.350.

Gregoria's feet, but it has long been noticed that she has her foot on something. It may be suggested that this is precisely the rock over the Orontes that is shown on the Antioch figure from the four Esquiline statuettes of eastern cities (Figure 1.4) and is clearly presupposed in the personification of the river on the Peutinger Table (Figure 1.10). The topography of the city is determined by a massive mountainous wall, as drawings and photographs readily make plain. But the name itself has still to be explained.

Cities often have several names in antiquity, not only in succession but also simultaneously. Jerusalem (Hierosolyma) was the Holy City, and Nikephorion on the Euphrates was also Callinicum (named for a local worthy). The Syriac-speaking city of Tela, near Edessa, had the Greek name of Nikephorion and was known at the very same time to citizens of the fourth- and fifth-century empire by a third name: Constantia. Similar multiple names are known in modern times. Perhaps most interesting and pertinent is the old medieval Russian name of Tsargrad, which still appears in Pushkin and the Russian Romantic poets of his period. This city of the czar—the imperial city—is none other than Constantinople, seen from a Russian point of view. If there were another name for Antioch with some local association, this would not be at all surprising.

As it happens, a name change for Antioch is already on record. After the catastrophic earthquake of 526 and its aftershocks lasting into 528, the city clamored to be free of its past association with the Seleucid Antiochus of nearly a millennium before. The chronicle of John Malalas reports that in the archival documents of acclamations at the time, it is revealed that the people chanted out loud for the city's name to be changed. Someone observed an omen, and a written oracle was brought forth with the words: "You, wretched city, shall not be called the city of Antiochus [Καὶ σύ, τάλαινα πόλις, Ἀντιόχου οὐ κληθήσῃ]."[13] Jus-

13. Malalas, *Chronographia*, 443–444 (Bonn).

tinian then ordered the city's name changed to Theoupolis ("city of God"), which subsequently appeared on the exergue of its coins. The name "Antioch" did not, however, disappear—nor, it may be surmised, did the people's desire to have a different name. On present evidence, in the eastern Mediterranean no city was more receptive to polyonymy than Antioch.

Hence, it is important to notice that at the time of the Madaba mosaic from the Room of Hippolytus, the dynamic and celebrated patriarch of Antioch was Gregorius. Pierre-Louis Gatier has acutely noted this fact in his commentary on the mosaic's inscription for the series *Inscriptions Grecques et Latines de la Syrie*.[14] The luminous character and courageous exploits of this Gregorius were chronicled in lavish and loving detail in the ecclesiastical history by Evagrius, who knew him. At the end of the sixth century, therefore, Antioch, the city in search of another name, was truly the city of Gregorius. It would have been entirely in the spirit of the artist, whose concern for his city and region raised Madaba to the level of Constantinople, to have identified Antioch by the name of its charismatic patriarch. The Antiochenes could not have been any more desirous then to have their old name than they were in 528. Even if the name of Theoupolis had not disappeared from rims of their coins by this time, they must have felt that "city of God" hardly gave them much individuality. In the days of the Roman Empire the numerous cities renamed Sebaste or Sebasteia, in honor of the emperor ("Sebastos" means "Augustus" in Greek), often struggled to have an additional, distinguishing name with some local color. In late antiquity Antioch overcame the banality of "Theoupolis" through the distinctive if now enigmatic "Gregoria."

14. Gatier, *Inscriptions de la Jordanie*, 1986, p. 126. See also his discussion in Piccirillo with Alliata, *The Madaba Map Centenary*, 1999, pp. 235–237, where he comments on my discussion of this matter at the Collège de France in 1997.

The image and name of Gregoria thus opens up, through its links to contemporary maps and cities, a coherent, self-conscious, and Hellenic world of Christian communities in the late-antique and early-Islamic Near East. These communities all tended to look westward, as well as up and down the coast of the eastern Mediterranean, rather than into the interior of Syria. The cities of the region clung to their independence and to one another at the same time. In this way, they remained strong both individually and collectively. That is presumably why a century after the victory of Islam they could still proclaim their identities in the language and style of the Greeks.

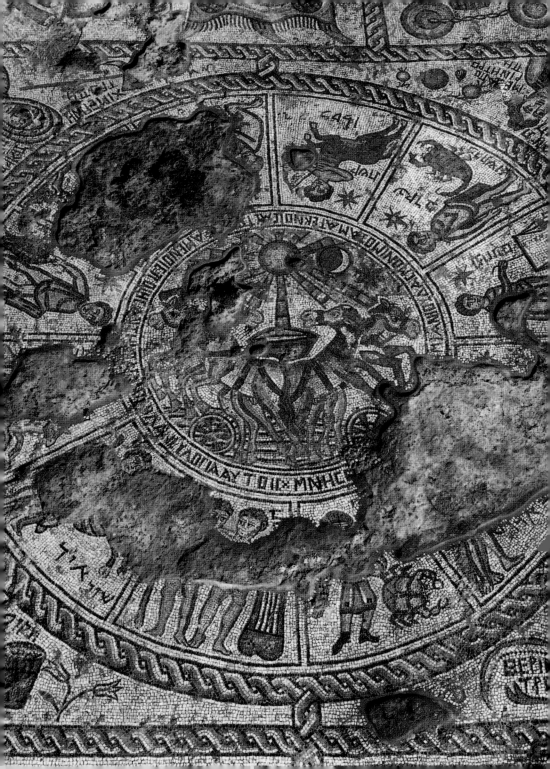

4

Iconoclasms

Anyone who examines the increasingly abundant mosaic art of the Near East from the late antique to the Umayyads must inevitably confront one of the most intractable and fundamental problems of early Byzantine history: iconoclasm, in various manifestations. The mosaics that serve for interpretations of myths, cities, and society in the region not infrequently bring before our eyes defaced or obliterated images. This is deliberate, not accidental damage. Some of the damaged mosaics have been known for a long time, but many are relatively recent accretions. They provide part of the basis for observations, from the perspective of art history, by André Grabar in his seminal work *L'Iconoclasme byzantin,* of some fifty years ago.[1] The implications of iconoclastic damage inside the Christian Byzantine empire naturally go far beyond images on mosaics and bear, first and foremost, on icons themselves; but in the Near East, under Muslim rule in a region where Christians lived, the mosaics are perhaps the most eloquent and puzzling witness to deface-

1. Grabar, *L'Iconoclasme byzantin,* 1984 (2nd ed.). For the aesthetics of Byzantine icons as representations of divinity, see Barber, *Figure and Likeness,* 2002.

ment in a world where the initiative for such action remains obscure to this day.

The central problem has traditionally been the apparent existence of two distinct and universal prohibitions of images within the same decade of the eighth century. One came from the Muslim side, the other from the Christian. We are told by several sources that in the year 721 the Umayyad caliph, Yazid II, issued a ban on the representation of all living things. We are likewise told that five years later the Byzantine emperor, Leo III, banned all representations of holy persons on icons. This applied to pictures of Christ, the Virgin, and the saints. Greek apologists later took a malicious and distinctly racist pleasure in blaming Leo's action on the influence of the wicked Arab Yazid, who was himself supposedly influenced by an even more wicked Jew. The whole subject has generated a vast scholarly literature.[2] It has served to support the unhelpful and overworked disjunction of *Orient oder Rom* as recently as L. W. Barnard's book of 1974, ominously entitled *The Graeco-Roman and Oriental Background of the Iconoclastic Controversy.*[3] Peter Brown was exaggerating perhaps only a little when he wrote in 1973, "The iconoclast controversy is in the grip of a crisis of over-explanation."[4] This remark served, however, as a preface to an explanation of his own, and I cite it here for a similar purpose.

The substantial number of mosaics from the region that were affected by Near Eastern iconoclasm of some kind is more than adequate justification for reopening the dossier of the controversy. We now have well over a hundred pertinent mosaics to instruct us, a treasure of docu-

2. Vasiliev's paper remains a good introduction to all this: "The Iconoclastic Edict," 1956.

3. *Orient oder Rom* was the notorious formulation of Josef Strzygowski in 1901. Cf. Barnard, *The Graeco-Roman and Oriental Background,* 1974.

4. Brown, "Aspects of the Iconoclastic Controversy," 1973, reprinted in *Society and the Holy,* 1982 (citation is on p. 254).

ments that transforms and deepens our study in many ways. The publication of Robert Schick's book on the Christian communities of Palestine from Byzantine to Islamic rule now makes available a convenient and systematic documentation of every known site and every known mosaic associated with those communities. He has himself registered in separate lists the more than fifty church mosaics with iconoclastic damage, and the more than seventy that survive undamaged.[5]

During the twentieth century the discovery of many figurative mosaics in Jewish synagogues revealed iconoclastic damage that is clearly similar to the defacement found in Christian churches. Synagogues, like churches, sometimes displayed secular images as well as holy ones—Thalassa ("the sea"), for example, in a Christian context (Figure 2.11), is famously matched by Helios in a Jewish context, as in the central medallion of a zodiac mosaic in the synagogue at Beth Alpha (Figure 4.1).[6] Steven Fine has written, "Iconoclastic behavior within synagogues is evidenced at a number of sites. . . . Characteristic of Jewish iconoclastic behavior, just enough of the image was removed so as to render it acceptable, and no more. The careful removal of images, as opposed to their haphazard destruction, may often be taken as a sign of Jewish iconoclasm."[7] The same could be said of Christian iconoclasm.

These developments have had a major, if confusing impact on views of the relations between Christians and Jews in late antiquity and early Islam. An argument has been made but by no means widely accepted that the Jews removed images or eventually chose to avoid them in syna-

5. Schick, *The Christian Communities of Palestine,* 1995.

6. The images of Helios are well presented and discussed in Kühnel, "The Synagogue Floor Mosaic in Sepphoris," 2001. The Sepphoris synagogue mosaic has now received a magnificent and definitive publication in Weiss, *The Sepphoris Synagogue,* 2005.

7. Fine, "Iconoclasm and the Art of the Late-Antique Palestinian Synagogues," 2001 (passage quoted is on p. 189). Fine has recently returned to this subject in his *Art and Judaism,* 2005, especially on pp. 94–97 and 121–123.

4.1. THE MOSAIC AT
BETH ALPHA, AS DRAWN
BY E. L. SUKENIK.

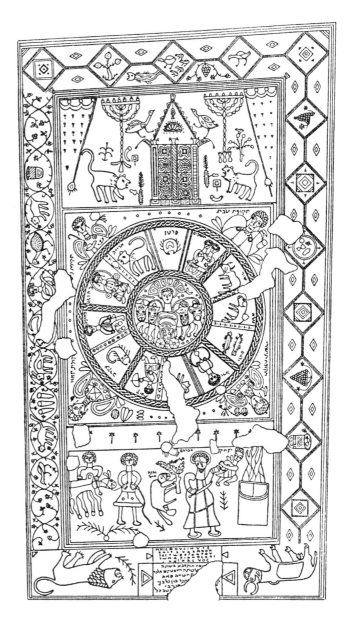

gogues precisely in order to distance themselves from Christians and their holy icons. But the damage itself really looks no different from the damage in churches, nor does the use of images seem all that different. The traditional distinction that art historians long drew between Jewish art and Christian art has now been eloquently demolished by Jaś Elsner, and the elimination of this false dichotomy opens up the possibility of a common fate for the art of both religions.[8] As for the Muslims, as far as we know, no mosque ever had figurative representation at all, but the Umayyad château at Quseir al-'Amra certainly did.[9] Although time has damaged its lively images, the iconoclast's chisel has not. But the images at 'Amra were not holy, nor were they in a sacred space.

The simple recitation of the available testimonia shows how far removed we now are from the view that J. W. Crowfoot expressed in the publication of the excavations at Gerasa in the 1930s. He wrote at that time, "The fruits of Yazid's decree have been found in many places in Palestine, Transjordan, and Egypt. In Gerasa the order was executed with the most punctilious discrimination. Inscriptions, decorative patterns, and pictures of buildings were spared, but all representations of living creatures were ruthlessly destroyed. The sorry way in which the mutilations, including mosaics, were repaired and patched up after the iconoclastic outbreak in Yazid's reign shows the wretched plight of the Christians, though it proves also that the community survived and still used the churches." A. A. Vasiliev cited these words with approval in his posthumously published paper of 1956 on the edict of Yazid.[10] Schick's register now demonstrates beyond any dispute that all representations were not ruthlessly destroyed. To be precise, they were neither all destroyed nor were they ruthlessly destroyed. With characteristic thoroughness, Schick posed the important question whether those that survived might

8. Elsner, "Archaeologies and Agendas," 2003, 114–128.

9. G. Fowden, *Qusayr 'Amra*, 2004.

10. See Vasiliev, "The Iconoclastic Edict," 1956, p. 45, quoting J. W. Crowfoot, Carl H. Kraeling, ed., *Gerasa, City of the Decapolis* (1938), p. 172.

have been covered over through rebuilding before the time of the edict so as to be no longer visible. He was able to prove, as we shall see, that although this was true in some cases it was not in many others.

Study of the *querelle des images* starts necessarily with the two quite different forms of prohibition. Leo was concerned exclusively with holy images or icons, not with representations of all living things. Further, Leo was by no means the first to find fault with devotion to icons. An iconoclast movement in Armenia has been identified before his reign,[11] and we have conciliar sources documenting a debate over icons in Asia Minor several years before he acted. In 724 Germanus, the patriarch of Constantinople, wrote to Thomas of Claudiopolis in Bithynia concerning a policy of iconoclasm that Thomas had already instituted locally. Germanus' opposition to this practice was so strong that he was removed from office in 730 for refusing to sign the emperor's edict.[12] At the iconoclastic council of Hiereia in 754, an anathema was pronounced on him as "the worshipper of wood." From the patriarch's communication to Thomas, which has been preserved in the proceedings of the Second Council of Nicaea in 787, it is clear that some Christians had been stung by criticism from Jews and Arabs, who were unalterably opposed to the worship of holy images. But there is no secure basis for assuming that they were influential in establishing Leo's policy.

Although considerably later texts hint at trouble over images in Egypt before Yazid, there is no comparable background of controversy for his edict as there was for Leo's. The issue in Palestine was substantively different from that in Byzantium. Far more than icons were at stake, and there was a conflict between two faiths rather than a division within one. It is clear from dated mosaics of the sixth and seventh centuries that no Christian community in the Near East felt any inhibition about the depiction of living things before Yazid. Moreover, the Qur'ān has no prohibi-

11. Alexander, "An Ascetic Sect of Iconoclasts," 1955.
12. See Theophanes, 409 (de Boor).

tion against such images, and it is obvious from the Umayyad frescoes at Quseir al-'Amra in Jordan or the Abbasid images at Samarra that Muslims were not themselves averse to representing living beings.[13] It was in the literature of the Hadīth that Muslim theologians eventually developed an explicit doctrine against the portrayal of anything that possessed *ruḥ* (breath), but since the Edict of Yazid was, as we are told, revoked after his death, it is obvious that this doctrine, which was manifestly applied to mosques, had little impact on art in private houses or Christian churches. The action of Yazid must probably be construed as an aberrant and overzealous extension of this doctrine.

It is easy to understand why some orientalists were prepared to eliminate the edict from history as simple fiction. Not only is it aberrant: the sources for it are, in most cases, largely Greek and highly suspect. There is no mention of it before the embarrassed deliberations of the iconophiles, or iconodules (as they are sometimes called), at the Second Council of Nicaea, more than a half-century after Yazid's death, and the account of it at that council blames the whole affair on a Jewish magician called Tessarakontapechus who persuaded Yazid to ban images in return for a guarantee of a long life (an extra thirty years as ruler). The tendentious character of this narrative speaks for itself. The text's reliability is instantly impugned by its statement that Yazid failed to secure his long life and died only a few years later, leaving his realm to his son Walid. The fact is that he was succeeded by Hisham, who ruled for nearly twenty years before Walid acceded to the caliphate. This Greek tale reappeared, with minor variants, in the Chronicle of Theophanes.[14] The Jew in Theophanes bears the more pronounceable name of Beser, which Vasiliev

13. On 'Amra see G. Fowden, *Qusayr 'Amra,* 2004. On Samarra, see Herzfeld, *Die Malereien von Samarra,* 1927.

14. The council proceedings can be read in Giovan Domenico Mansi, *Sacrorum conciliorum nova et amplissima collectio* (Florence and Vienna, 1759–1798; rpt. Paris, 1901–1927), vol. 13. For Theophanes, see now Mango and Scott, *Chronicle of Theophanes,* 1997, p. 555 (pp. 401–402 de Boor).

credulously thought was a second name for Tessarakontapechus. The story continues its life in the writings of the ninth-century patriarch Nicephorus, as well as in Georgius Monachus and Cedrenus. But more impressive than any of this testimony is the silence of John of Damascus, who, writing voluminously in the very century of the edict and himself deeply concerned with iconoclasm in his *De haeresibus,* says nothing about it.[15]

The existence of systematically damaged mosaics seems, nonetheless, to presuppose something along the lines of the Edict of Yazid. The few but substantive allusions to it in Arabic sources provide a certain credibility that the Greek stories lack. Al-Kindi in the tenth century ascribes to Yazid an order to obliterate images and break statues, and several centuries later al-Maqrizi gives a similar brief report. A Coptic Christian, Severus ibn al-Muqaffa, writing in Arabic at about the same time as al-Kindi, is also aware of the edict, and he knows, unlike the Greek writers, that Hisham, not Walid, succeeded Yazid and abrogated his order. It seems evident that the edict cannot be swept away.[16]

But who defaced the mosaics, and when did they do their destructive work? The answers to these questions can illuminate the Edict of Yazid. Hitherto many of our problems have arisen from attempting first to illuminate the mosaics *by* the Edict of Yazid. Since the nature of the damage reflected a characteristically Muslim doctrine against images of living creatures, it was all too easy to assume, as Crowfoot did, that bands of Arabs invaded the churches of Palestine and Transjordan under instructions from the caliph to wrench out the offending tesserae from their pavements. But the many mosaics that are now available for study reveal—as both Piccirillo and Schick have stated unambiguously for the Christians, and Charles Barber and Steven Fine have shown for the

15. Vasiliev, "The Iconoclastic Edict," 1956, provides the basic information for all this.

16. On al-Kindi and Severus, see Vasiliev, "The Iconoclastic Edict," 1956, p. 39.

Jews—that the coreligionists themselves did the damage.[17] This is an important step forward in understanding what happened.

With a very few exceptions, which can easily be explained as later vandalism after the pavements had fallen into disuse, the damaged mosaics in churches and synagogues show that the perpetrators of the damage exercised meticulous care in removing tesserae from offending images (Figures 4.2, 4.3, 4.4). In numerous instances the shape of the original image, whether human or animal, can be distinctly perceived, and in some cases only parts of the image were removed so that a neck or a torso survived intact. Furthermore, in most cases the repair to the damage is so carefully adapted to the pavement by means of the laying of comparable cubes (and sometimes the same cubes that had been removed) that those who did the damage must be assumed to be the same as those who repaired it with aniconic filler. Such concern for inflicting minimal damage on the pavements, as well as for making prompt and appropriate repair, points obviously to the worshipers themselves as the agents of this work. The inference seems confirmed by a notable repair at Masuh in which the replaced tesserae form an image of the cross.[18]

Let us leave open for the moment the date of Jewish iconoclasm. Apart from Seth Schwartz, who recently connected the damage in synagogues with a "wave of iconophobia" in the eastern Mediterranean,[19] there has been a tendency to place such damage, especially the examples at Na'aran, before the eighth century and therefore before that wave of iconophobia. It is generally assumed, however, that the Christians did

17. See Schick, *The Christian Communities of Palestine*, 1995 (ch. 9, "Iconoclasm"), followed by Piccirillo in many publications. On Jewish iconoclasm, see Barber, "The Truth in Painting," 1997; and Fine, "Iconoclasm and the Art of the Late-Antique Palestinian Synagogues," 2000.

18. Schick, *The Christian Communities of Palestine*, 1995, pp. 404–405.

19. Schwartz, "On the Program and Reception of the Synagogue Mosaics," 2001.

4.2. DEFACED FIGURES WITH SMALL CITIES IN THE MOSAIC AT THE CHURCH OF ST. STEPHEN, UMM ER-RASAS.

the best they could to implement an unwelcome order. Since the nature of their iconoclasm in the Near East is, as we have seen, wholly unlike the Byzantine prohibition of holy icons, there is no reason whatever to assume that the damage in Palestine and Transjordan arose from an internecine doctrinal dispute among Christians. Furthermore, the Christians could have had no reason to anticipate in advance an order to eliminate images of living things, inasmuch as even in the late seventh and early eighth centuries they were still laying down mosaics with images in their churches.

At least five securely dated mosaics over a broad geographic area may be invoked. The new excavations at the basilica of St. Lot at Deir 'ain

4.3. DEFACED ANIMAL IN THE MOSAIC AT THE CHURCH OF ST. GEORGE, GERASA (JERASH).

'Abata south of the Dead Sea have uncovered a mosaic in front of the chancel that is dated to 691. It displays bird and animal images that escaped iconoclastic damage altogether. We can be sure of this since Abbasid pottery was found at the site. At Quweisma another dated mosaic with images, this time damaged, is securely dated to 717–718. The work may well have been in response to the earthquake of that time, since two other important dated mosaics belong to the years immediately following. At Umm er-Rasas in 718, as now appears from Schick's important study of the disturbed tesserae of an inscription in the Church of St. Stephen, a rich mosaic full of images of both benefactors and animals was laid down in the central nave, only to be damaged and repaired subsequently.[20] In 719–720 at Ma'in, not far away, craftsmen laid and dated yet another mosaic with images, which were later damaged and re-

20. See the thorough documentation in Ognibene, *La chiesa di Santo Stefano ad Umm al-Rasas*, 2002.

4.4. THE MOSAIC AT
NA'ARAN, WITH
ICONOCLASTIC
DAMAGE.

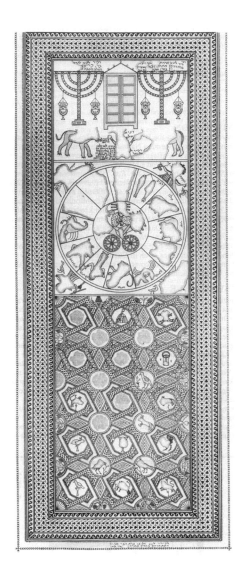

paired. Finally, to the north we have a dated mosaic of 722 with undamaged images at Deir al-'Adas.[21]

It is absolutely clear that Christians in this region were depicting without anxiety all manner of living beings as late as the accession of Yazid in 720. It is equally clear that when the damage was done, they did it themselves with careful attention to preserving the integrity of their pavements as much as possible. In a small number of instances, as in the Church of St. Lot at Deir 'ain 'Abata or in one of the churches at Khirbet en-Nitla (east of Jerusalem) that was in use until the end of the Umayyad period, the local Christians seem never to have undertaken the unpleasant work of iconoclasm at all. Even at sites in which they did inflict some damage, not all the images were affected. The Church of St. George at Gerasa shows both intact and repaired images within the same pavement, as does the great mosaic at the Church of St. Stephen at Umm er-Rasas. We can explain this situation only by assuming that the unexpected order to destroy images was in force for a very short time. The partial nature of the iconoclasm and the supposition that it was only briefly carried out may well be the reason that John of Damascus found no cause to talk about it in his treatment of the larger issue that convulsed the Byzantine Christian world.

The mosaics do not tell us exactly when the iconoclasm occurred, but they at least provide a terminus of 720, the date of the latest damaged mosaic. A new pavement put into the Church of St. Stephen at Umm er-Rasas in 756, according to the date it provides (still, interestingly, by the era of the Roman province of Arabia), is entirely decorative and may conceivably reflect some caution in the matter of new images as a result of past trauma. Or perhaps, coming as it did only two years after the notorious iconoclast council of Hiereia in 754, it reflects nervousness and un-

21. For these examples, see Schick, *The Christian Communities of Palestine,* 1995, pp. 398–399 (Ma'in); 217 and 306 (Deir al-'Adas).

certainty about future moves by overzealous Christian brethren. Possibly both explanations are valid. All we can say is that after 720 the Christians in the region felt obliged to carry out a program of iconoclasm for what appears to be too short a time to accomplish the work thoroughly.

This is the documentary background against which the testimony for the Edict of Yazid must be seen. We have already observed that the bulk of the evidence is late, Greek, and tendentious. Al-Kindi is the earliest Arabic writer to mention Yazid's ban. It was also known to the author of the Syriac Chronicle wrongly ascribed to Dionysius of Tell Mahre. It is possible that both writers received their information through Greek sources, but the eloquent mosaics speak plainly of a systematic iconoclasm after 720. Yazid died early in the year 724, on the twenty-seventh of January. An edict in his name could readily be imagined.

But the apparent brevity of its enforcement now requires a closer look at the exact date of its issue. The conventional opinion, found in Grabar, Vasiliev, and other standard studies, is 721. Yazid's successor is credited with abolishing the edict. Yet the condition of the mosaics would be hard to explain if the edict had been in force during the final three years of Yazid's rule. Curiously, only two of the sources that mention the edict give so early a date for it. These are the Greek report of the presbyter John of Jerusalem to the Second Council of Nicaea and the Arabic notice of the Coptic Christian Severus ibn al-Muqaffa. John the presbyter reported to the council that Yazid died two-and-a-half years after promulgating his edict, while Severus simply asserts that Yazid issued the edict at the beginning of his reign. We know that he took up the caliphate in 720. With these two items a scholarly consensus fixed upon 721. Even Vasiliev, who knew all the other relevant testimony,[22] opted to believe in this early date. His reason was a rather naive conviction that the earliest source, namely John the presbyter, deserved preference as such, even

22. Most easily consulted in his article "The Iconoclastic Edict," 1956.

though he realized that John's *bona fides* was called seriously into question by his bizarre mistake about the name of Yazid's successor.

Let us review the other testimony. Al-Kindi, the earliest Arab witness, explicitly dates the edict to the year 104 of the Hijra, which translates into 722/723. The Syriac Chronicle of Pseudo-Dionysius of Tell Mahre puts it in 723. Of later Greek authors, George the Monk, Cedrenus, and Zonaras, probably representing a single tradition, all declare that the edict was issued less than a year before Yazid's death at the end of January 724. Theophanes takes care to record the date of the edict by five different systems of reckoning: the era of Alexandria, the year of Leo III at Constantinople, the year of Yazid himself, the year of the patriarch of Constantinople, and the year of the patriarch of Jerusalem.[23] The five reckonings all deliver the same date, 723/724. Hence we have a solid basis for abandoning John the presbyter and accepting these converging witnesses. By doing so, we put the Edict of Yazid into the last months of 723. Such a date would allow for a period of enforcement of no more than three or four months—a period that would manifestly suit the evidence of the mosaics far better than a period of two-and-a-half years. In addition, the undamaged pavement of 722 at Deir al-'Adas would also make better sense with the later date. Otherwise we would be obliged to assume either that the authorities at that monastery were recklessly courting trouble or had somehow not heard the news.

We should remember that many of the most vivid of the representational mosaics that have occupied us since we first confronted the mystery of Gregoria were no longer visible in the time of iconoclasm. The room of Hippolytus, with Phaedra, Aphrodite, the Erotes, and the three cities, had long since disappeared under the floor of the Church of the Virgin at Madaba. The spectacular images in the Church of St. Lot and

23. Theophanes (de Boor), p. 401; and Vasiliev, "The Iconoclastic Edict," 1956, pp. 46–47.

Procopius at Khirbet al-Mukhayyat had also become invisible. It appears that what happened in 723 was an action taken specifically against Christian churches. There is little or no reason to think that any images in private dwellings were affected. A recently discovered house in Gerasa may possibly furnish a single counterexample, but the damage could also be explained as the result of a natural disaster.[24] In view of the Muslim tolerance of such images in their own private quarters, there is every reason to assume that such places were, in general, unaffected.

We may now return to the case of Jewish iconoclasm, which is less substantially documented but nonetheless clear and pertinent. The damage wrought in synagogues exactly resembles the meticulous disfigurement and replacement that can be seen in churches. Interpreters, such as Charles Barber and Ernst Kitzinger, have been disinclined to explain Na'aran by reference to the Edict of Yazid, not least because of the traditional opposition to images among Jews themselves. But that was an opposition that was called gravely into question by the discovery of the paintings in the Dura synagogue and equally by the mosaics at Na'aran, Beth Alpha, Hammat Tiberias, Sepphoris, and elsewhere.[25] The rabbis may have been, as often observed in recent years, hostile to representational imagery to which one bowed down but could in other instances be ambivalent or positively accepting.[26]

24. Z'ubi, Gatier, Piccirillo, and Seigne, "Note sur une mosaïque à scène bachique," 1994.

25. Cf. Kühnel, "The Synagogue Floor Mosaic in Sepphoris," 2001, as well as the full publication of the Sepphoris synagogue: Weiss, *The Sepphoris Synagogue*, 2005. The powerful images in the Dura synagogue from the third century have been repeatedly discussed. See Rostovtzeff, *The Excavations at Dura-Europos*, 1936. The synagogue paintings are now kept in the Damascus Archaeological Museum. See now Fine, *Art and Judaism*, 2005, pp. 83–97, for the synagogue mosaics.

26. See Schwartz, "On the Program and Reception of the Synagogue Mosaics," 2001; and Fine, "Iconoclasm and the Art of the Late-Antique Palestinian Synagogues," 2001. Fine adduces an interesting case of a possible talmudic defense of images. He has returned to the Sepphoris zodiac in his recent book *Art and Judaism*, 2005.

ICONOCLASMS

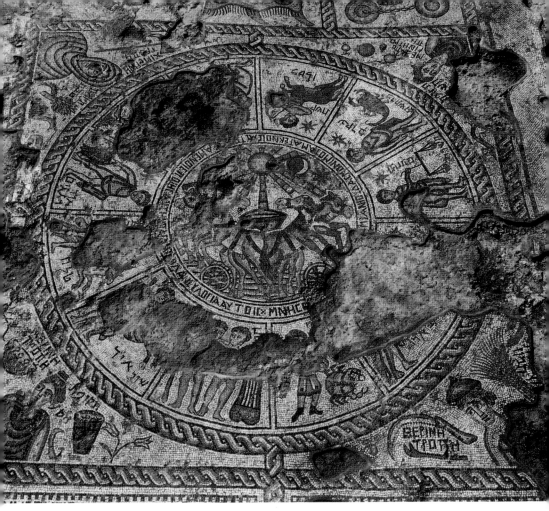

4.5. THE ZODIAC MOSAIC FROM THE SYNAGOGUE AT SEPPHORIS.

The possibility that the Jews themselves introduced iconoclasm, for whatever reason, might be supported by the curious and unparalleled avoidance of a figure for Helios in the Sepphoris mosaic (Figure 4.5), but this anomaly in a synagogue that is so full of images of persons can be much better explained in other ways. The figure of Helios actually does appear in other Jewish mosaics, at Na'aran, Hammat Tiberias, and Beth Alpha. (Both the sun and the moon appear in the mosaic of a monastery at Beth She'an.)

The mosaic at Naʻaran, with Helios and zodiacal figures, provides the most arresting of the many examples of Jewish iconoclasm (Figure 4.4). The defacing was thoroughly but carefully done, so as not to touch the numerous inscriptions in the mosaic carpet of the nave of the synagogue.[27] Schwartz's "wave of iconophobia" could easily be converted into implementation of Yazid's edict, exactly as we see in the churches. It has often been observed that precisely in the eighth century at Jericho, not far from Naʻaran, one of the latest synagogue mosaics was laid, and this one was resolutely aniconic. It is hard not to suspect the influence of the recent prohibition of images. Such a reassessment of eighth-century iconoclasms in the Near East would at least allow us finally to lay to rest one of the most unattractive of the older hypotheses about damage to the Christian churches: that it was actually carried out by Jews.

Fine's most recent interpretation of Jewish iconoclasm in the Muslim world makes more sense of this phenomenon than any other: "Jews simply adopted and adapted the aesthetics of the new colonial power."[28] The traditionally anti-image strain in Jewish culture enabled the Jews of Palestine to accommodate the wishes of the new governing authority by returning to their deeper roots, uncontaminated by Graeco-Roman art. Hence they were willing to move away from a visual vocabulary that they had found attractive for centuries under Byzantine administration. This explanation is at once more nuanced and more realistic than the allegation, sometimes advanced, that the Jews were showing their hostility to the apparent idolatry of Christian icons.

27. See Fine, "Iconoclasm and the Art of the Late-Antique Palestinian Synagogues," 2001, pp. 189–190, for a useful review of the more significant examples of what he calls iconoclastic behavior that was "indeed quite common." See now Fine, *Art and Judaism*, 2005, pp. 82–97, for a full discussion of Naʻaran and other examples of iconoclasm. Schick, *The Christian Communities of Palestine*, 1995, p. 203, also gives a list of iconoclastic damage in synagogues.

28. Fine, *Art and Judaism*, 2005, p. 123.

What is needed now is some plausible explanation as to why Yazid, at the end of his life, undertook to impose such unexpected harassment upon the non-Muslims in his realm. Few will be prepared to believe John of Jerusalem's fairy tale about the Jewish magician who offered the caliph a long life in return for iconoclasm. It may be, of course, that Yazid conceived a desire simply to remind the Christians and Jews that they were aliens in a Muslim world. But perhaps we should consider another possibility.

A mosque uncovered relatively recently at Be'er Orah in the Negev turned out surprisingly to have two prayer niches. Since the prayer niche (or *qibla*) traditionally faces toward Mecca, in the Negev it should have faced roughly south. One of the *qiblatain* at Be'er Orah does indeed face south, but this is the later of the two. The earlier *qibla* faces east *(qibla musharriqa)*. A few years ago, in addressing the problem posed by this feature, Sulayman Bashear succeeded in producing substantial documentation for direct Muslim involvement with Christianity in the early centuries of Islam.[29] He pointed out that Mu'awiyya, who was crowned in Jerusalem, prayed on Golgotha and formalized his agreement with 'Amr ibn al-'As inside the Church of the Theotokos. Such a Muslim use of a Christian church appears not to have been all that unusual at the time. 'Umar ibn al-Khattab is recorded to have prayed on the steps of the Church of the Resurrection in Jerusalem, as well as in the church at the tomb of the Virgin Mary at Gethsemane. An Umayyad governor of Iraq actually built a Christian church at Kufa in honor of his mother, who was Christian. We are told that none other than Al-Mansur, the second Abbasid caliph, contributed to the construction of a church in Damascus. In the early tenth century Eutychius of Alexandria, a Christian writing in Greek, had occasion to complain that Muslims of his day came together to pray in churches in both Bethlehem and Jerusalem. Robert

29. Bashear, "Qibla Musharriqa and Early Muslim Prayer," 1991.

Hoyland has also invoked Muslim use of Christian monasteries.[30] Accordingly, Bashear associated the eastward-looking *qibla* with such use of Christian holy places in the early Islamic period. His study concluded that throughout Palestine and Transjordan in the first few centuries of the Hijra, Muslim use of Christian churches for prayer was by no means rare.

If this is the case, it becomes possible to understand why the caliph would have had an interest in making churches conform to the strict injunctions that were applied to mosques and found expression in the Hadīth. It is clear from Hisham's prompt abrogation of Yazid's edict that there was a general sentiment in the land that Yazid had gone too far in interfering with the buildings of Christians in his territory. The possibility remains that Yazid may simply have been more hostile to Christians than most Muslim rulers. But if for those early centuries of Islam there is, as there seems to be, convincing evidence for the Muslim use of churches, the true motive for iconoclasm is more likely to have been active involvement with Christian edifices rather than hostility to them.

We need now to ask whether synagogues had a comparable religious significance for the Muslims. The possibility is worth thinking about, since Jewish iconoclasm in other respects is better explained as parallel to the Christian iconoclasm rather than as an anterior reaction to Christian use of images. Since it is now apparent that the mosaic decoration of synagogues showed close parallels with Christian mosaics, the Muslim conquerors, who knew perfectly well the Jewish origins of Christianity, must have been aware of the holiness of synagogues. More to the point, they would have known that from the later fourth century until the early sixth a kingdom of ethnic Arabs in South Arabia had converted to Judaism and maintained their religion, not all that far from Mecca itself,

30. Hoyland, Review of Schick, *The Christian Communities*, 1998. See also Zayyat, "Al-diyārāt al-naṣrānīya fī 'l-islām," 1938.

until the Christians of Ethiopia brought it to an end.[31] So Muslim Arabs knew from their own immediate past the holiness of synagogues, just as much as they knew the holiness of churches.

In the iconoclasm of the eighth-century Near East we seem, therefore, to have yet another example of the merging of earlier traditions in the newly arrived world of Islam. Late antiquity and early Islam are full of challenges to old easy dichotomies, such as *Orient oder Rom,* that have so long dominated historical interpretation. Christianity and Islam were just beginning to know each other in the first centuries of the Hijra. Hellenism and the Greek language visibly took a long time to expire in the region. Judaism and Christianity never did.

The Muslims won their rule of the Near East by conquest, but they inherited a people with long memories of language, culture, and religion. With the mass of mosaics that now lie before us from both sacred and secular buildings ranging over three centuries, from the sixth to the eighth, we can see as never before what those memories were like and how they were forged. When the Muslims came, they had no choice but to embrace the past. In taking over a world full of Jewish synagogues and Christian churches, they could not avoid acknowledging the power of that past even as they sought to transform it.

31. Bowersock, "The Ḥaḍramawt between Persia and Byzantium," 2004. See also the important article by Beaucamp, Briquel Chatonnet, and Robin, "La Persécution des chrétiens de Nagrā " 1999–2000. The struggle of the Christian Ethiopian king Kaleb Ella Asbeha against the Jews of South Arabia is commemorated in chapter 117 of the *Kebra Nagast,* the holy book of Ethiopian Christianity.

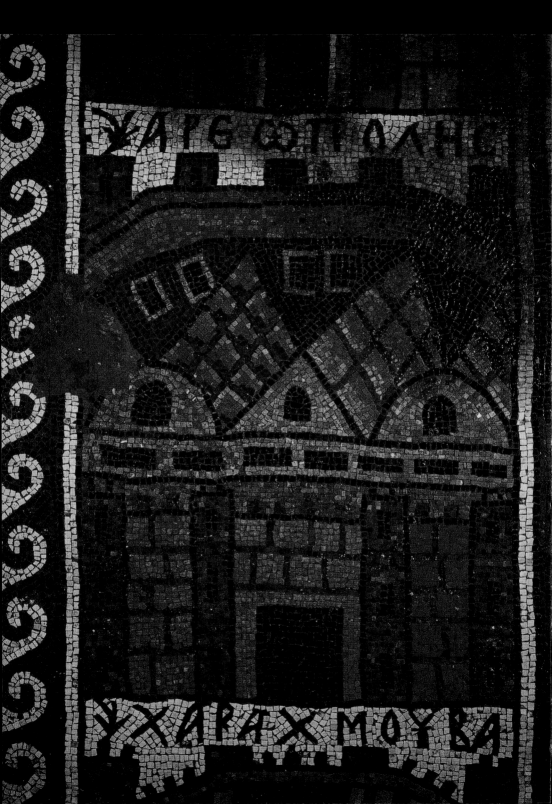

5

Contexts

Mosaics were widespread in the late-antique Mediterranean world. The explosion in the popularity of this kind of interior design was by no means confined to the Near East. The diffusion of representational mosaics increased dramatically over the Roman Empire from the third century onward. Study of this art has become a highly productive industry, and our understanding of iconography in late antiquity has been enriched immeasurably.[1] But the Near East in particular offers an unusual laboratory for investigating mosaics as historical documents that can inform us, much as inscriptions or papyri, about the religion and society of the region. This is not so easily done for other areas rich in mosaics, such as North Africa. There the proliferation of private villas and fortress-villas in a world that was torn apart by internecine struggles among Christians, as every reader of Augustine will know, made it much less

1. Colloquia and publications are fostered by the vigorous Association Internationale pour l'Etude de la Mosaïque Antique (AIEMA). For a list of conference publications by AIEMA, see the useful website of the Association for the Study and Preservation of Roman Mosaics (ASPROM): www.asprom.org/resources/bibliography.html. For a magisterial overview, see Dunbabin, *Mosaics of the Greek and Roman World*, 1999.

possible for a universalizing art to express a shared culture. There was much less of a shared culture.

The Near East in late antiquity has been uncommonly generous in delivering up its mosaic treasures from churches and synagogues. Here the new mosaic finds, starting with the accidental discovery of the Madaba map, have opened up unexpected vistas into the society of the region not merely through the adornment of private dwellings but, more importantly, through the pavements in places of worship. And the profusion of mosaics has extended, as we have seen, well into the Muslim period. Accordingly the Near East, over more than four centuries of late antiquity and early Islam, provides an unparalleled opportunity to examine both tradition and evolution in the religion, society, and culture of what, in earlier centuries, had been simply the Roman Near East.

It may be useful to consider the special features of the area as it changed from an aggregate of provinces administered from old Rome in Italy to a vast but cohesive territory under surveillance from the new Rome at Constantinople and later Damascus, yet always with a high degree of local autonomy, especially in the south.

First and of supreme significance is the long era of relative peace that settled upon the Near East after the suppression of the Revolt of Bar Kokhba in the waning years of the emperor Hadrian. This era of peace lasted, with a few localized interruptions, all the way down to the Persian capture of Jerusalem in the early seventh century. It is true that after the Sassanians took over the rule of Persia in 222, the Persians represented the principal counterweight to Roman and subsequently Byzantine imperial authority. But their conflicts were largely played out at the fringes of empire, where Caracalla and Julian died. Dura on the Euphrates succumbed to the Persians when they invaded Syria in the mid-third century, and the great city of Antioch had some frightening moments when the Persians crossed northern Syria in the sixth century. Similarly, on the southern fringe, in the Arabian peninsula, some real horrors took place

in the sixth century, when an Arab king, who had converted to Judaism, massacred the Christians of Najrān.[2] But generally in Palestine, coastal and southern Syria, and provincial Arabia (Transjordan), there was peace for most of the time. The Samaritan revolts against the Jews in the fifth century were an internal quarrel, and the attempt of Gallus to usurp the throne of Constantius in the fourth had no long-lasting impact on the life or culture of the Near East. These episodes were not unlike the ill-fated and short-lived attempt of the Arab queen Mavia, who had converted to Christianity in the fourth century and tried to take over the Near East.[3]

What secured the relative tranquility of the region was its extraordinarily mixed culture. Many religions and many peoples cohabited together and shared Hellenic traditions they had all inherited. The diversity of the population on the ground is fundamental to understanding the world that the mosaics have exposed. From the beginning the ancient Near East was a land of Arabs of various kinds, both nomadic and sedentary, literate and illiterate, and, at the same time, of Jews of various kinds, with a religion that had its roots in the Mosaic dispensation. The arrival of Alexander the Great imported Greek language and culture. Hellenism took hold right from the start. Its influence on the Arabs can easily be seen in the theaters and temples of the Nabataeans and Palmyrenes, and on the Jews in the time of the Maccabees and Herod the Great. With the annexation of provinces in the region—Syria in 63 B.C.E, Judaea in 6, Arabia in 106—came Roman authority, Roman law, and Roman legions, to say nothing of the Latin language in the camps of the soldiers. The Roman Near East now included pagans of many stripes. The Roman pantheon was worshiped by legionaries alongside the gods of the Greeks and pre-Islamic Arabian divinities that were already known to Herodo-

2. On Antioch, see Downey, *History of Antioch in Syria,* 1961. On Najrān see Shahîd, *Martyrs of Najrān* 1971.

3. Cf. Bowersock, "Polytheism and Monotheism," 1997; and idem, "Urheber konkurrierender transzendentaler Visionen," in *Selected Papers,* 2000, pp. 83–91.

tus.[4] Confronted with the Roman occupation, the Jews tried twice to rebel, once in the first century and once in the second. With the evacuation of the Jewish population from Jerusalem, apart from one day each year, in the aftermath of the suppression of Bar Kokhba, Judaism prospered in other cities of what was now Palestine. As we have seen, the Patriarch took up residence in Sepphoris. Meanwhile Christianity was slowly making its way into history in precisely this part of the world.

At the dawn of late antiquity, when the Sassanians were just beginning to assert themselves in the third century, the kingdom of Palmyra subsided in defeat after a vain attempt by Zenobia to exploit a power vacuum in the days of the emperor Aurelian. When the tetrarchs divided up the empire, Roman authority was clearly waning in the area, and both Latin and legions declined, along with their gods.

Two major events in the ensuing reign of Constantine set the Near East on the course we have been pursuing through the mosaics. The first event was the emperor's conversion to Christianity and the subsequent establishment of Christianity as the state religion of the empire. The second was the removal of the central administration from Rome to the newly named Constantinople at Byzantium. The city on the Bosporus was soon to be recognized as a second Rome, or, in the words of the Cappodocian father Gregory of Nyssa, the "newborn Rome." By the early fifth century the city could simply be called Rome without further specification, and by the sixth century it is likely that, in the Near East at least, those who were not scholars or theologians did not even know what or where old Rome actually was. Under Islam Rome was frequently described with the topography of Constantinople, even if miracles associated with the city belonged to the Italian capital.[5]

4. Note Herod I.131 and III.8, referring to the Arab divinities Alilat (clearly Allāt) and Orotalt/Orotal (possibly Dūshara).

5. See Gregory of Nyssa, in *Anthologia Palatina*, 1.5: "νεοθηλέα Ῥώμην." And recall the hospital mosaic (invoked in Chapter 2) from Syrian Frikya. It is now in Maʿarat an-Nuʿmān

Mosaics are primary sources for this transformation of the Near East from a Roman provincial outpost into a thriving and cohesive center of Hellenism, where Jews, Christians, and pagans lived side by side and in peace most of the time. The pagan community was itself diverse, preserving old traditions of Arab polytheism, with local shrines for indigenous deities, alongside the whole pantheon and mythology of Greek polytheism. The Roman gods faded, along with the Latin language, although neither disappeared entirely, as a few late-antique Latin inscriptions bear witness. But the Near East of the mosaics was no longer the Roman Near East in the old sense. It was Roman only in the sense that "Rome" now meant Constantinople. This period in the region can best be called late antique, or, less usefully (because it cuts out Islam), simply early Byzantine.

Perhaps the most impressive result of the mosaic evidence, in aggregate, is the proof of an urban self-consciousness that was combined with Greek culture, whatever the ethnicity or religion of the people. This self-consciousness, which clearly lasted into the eighth century, is reflected in the numerous representations of cities all across the region. These images, which in some cases certainly attempt to depict real buildings, carry a heavy freight of culture and tradition. For example, at Umm er-Rasas we can see Areopolis among the cities displayed in Transjordan (Figure 5.1). This is modern Rabba, where the extant remains convey only the slightest sense of the former splendor of the place. But the name, written in Greek under Muslim caliphs, evoked many things from the past. Here is the city of Ares, the Greek god of war. But we happen to know that Ares in the city's name is a Hellenic substitute for the indigenous Arabian god Arsu. In fact, during a brief period of ethnic pride un-

and depicts Romulus and Remus with the wolf—as an emblem of succouring the helpless, manifestly without the slightest awareness of any reference to Rome in Italy: *Syria*, 64 (1987), 327; cf. Feissel in *Bulletin Epigraphique*, 1989, 971. On the Arabs see now the admirable study by De Simone and Mandalà, *L'immagine araba di Roma*, 2002.

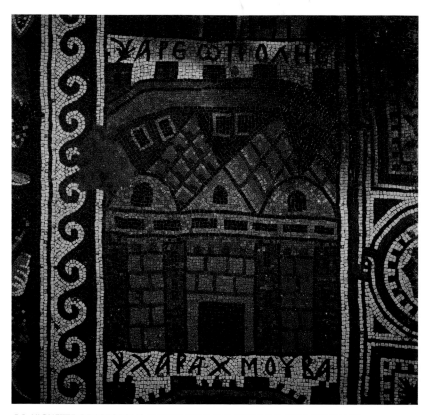

5.1. VIGNETTE OF AREOPOLIS (RABBA) FROM THE MOSAIC IN THE CHURCH OF
ST. STEPHEN, UMM ER-RASAS.

der the Syrian emperor Elagabal, the city changed its name to Arsapolis,
as its coins make plain.[6] This was a city of a local divinity in Greek garb,
asserting its ancient identity a hundred years after the Muslim conquest.

Similarly, as we have seen, Antioch on the Syrian coast changed its
name in the sixth century to Theoupolis as testimony to its Christian sta-
tus. It was proud to be the seat of one of the eastern patriarchs, and the

6. Bowersock, "An Arabian Trinity," 1986, especially pp. 19–20 with n. 11.

CONTEXTS

name of a Seleucid emperor from the Hellenistic age no longer suited its current ambitions. But then so banal a name as the "city of God" quickly lost its luster, and so, it seems, this great city—where Libanius had taught and where Syriac could be heard in the streets—chose to honor its own Gregorius by a name that only a mosaic has preserved for our instruction today.

The Jews, encompassed by Christian and Hellenic symbols, exploited the mosaic art that was everywhere around them to bring into their synagogues, and perhaps their houses, images that have surprised and enriched the modern world. Even if it was not the Jewish patriarch who contemplated the great mosaic scene of Heracles and Dionysus in a drinking competition, it was indisputably a Jewish congregation that watched Helios on his chariot at Hammat Tiberias or Beit Alpha, or pondered the curiously disembodied Helios that a highly inventive designer put into the synagogue at Sepphoris along with illustrations of Bible scenes. These artistic achievements show a cultural sophistication and assimilation that go far beyond the third-century paintings at Dura-Europos. They open up a Judaism that hardly anyone would have credited a hundred years ago. Again, mosaics have told us all this.

The revelation that Petra had a late-antique history at all has come only in the past decade—through excavation of the church in the center of the city, through study of the sixth-century carbonized papyri that were found in it, and through excavation at the shrine of Aaron high up on the Jabal Haroun.[7] We now have mosaics from Petra that fit perfectly into the picture that has been developed from other sites. The personification of the seasons at the Sepphoris synagogue has now been compared with a seasonal mosaic in the Petra church, and the mosaics in the Aaron

7. See Fiema, Kanellopoulos, Waliszewski, and Schick, *The Petra Church,* 2001; Koenen, Daniel, and Gagos, "Petra in the Sixth Century," 2003; and (on finds at Jabal Haroun) Frösen and Fiema, *Petra: A City Forgotten and Rediscovered,* 2002.

shrine, remote as they are, can be seen to have suffered the same meticulous iconoclastic damage as others in the Near East.

Above all, the hellenized Arab culture that was absorbed in the Umayyad empire finds eloquent expression in the Petra papyri from just over a half-century before the conquest.[8] These documents, written in Greek, reveal both the survival of Nabataean personal names and the emergence of Arab words into local Greek vocabulary. The familiar Arabic term for property, *māl,* shows up in the papyri as $\mu\alpha\lambda$. Other examples of the incorporation of Arabic terms into Greek are Arabic *ḥaram* (sacred space) as $\alpha\rho\alpha\mu$, and Arabic *bait* (house) as $\beta\alpha\iota\theta$. There are still more instances of this kind.

Until the early seventh century, in a world that was, by and large, peaceful and immensely diverse, Christians, Muslims, and pagans of all kinds shared a common heritage of Hellenism that gave expression to local, religious, and ethnic character. It seems clear enough that if the rabbis worked on Hebrew texts but wrote in Aramaic, the Jews around them could cope not only with those two languages but with Greek as well. The Sepphoris synagogue is a polyglot marvel, with inscriptions in all three languages. The Arabs in Petra were probably speaking Arabic, but they wrote their documents in Greek and attended a Christian church just across the street from a massive and enigmatic complex, with a theater and pool, that displayed masks of Dionysus. Christine Dauphin's detailed register of the Christian, Jewish, and pagan communities of Palestine constitutes a modern map of the exceptional diversity of late-antique Palestine, much as the Madaba map had done in a mosaic from late antiquity itself.[9]

8. Frösen, Arjava, and Lehtinen, *The Petra Papyri,* 2002. The material has been divided between Finnish papyrologists in Helsinki and American papyrologists in Ann Arbor, Michigan. We are still waiting for the Michigan team to publish a most important document, inv.10, of more than 150 lines.

9. Dauphin, *La Palestine byzantine,* 1998.

All this diversity fell victim equally, it would seem, to the iconoclastic initiative of the eighth century. The damage in Christian churches, particularly when set alongside what happened in Jewish synagogues, suggests that the order came from the Muslim side, and that it was carried out by the protective hands of the faithful themselves in each case. The dating for the Jewish figural mosaics is far more problematic than for the Christian ones, and it is still impossible to say with certainty that Jewish iconoclasm did not occur before the eighth century or even before the conquest. But the odds are overwhelming in favor of a coincidence with the Christian examples. The overtly aniconic program of the Jericho synagogue in the eighth century, not far from the defaced Na'aran mosaic, points to the same assumption. Similarities with Christian damage are impressive, and there is no obvious context for an earlier outbreak of this kind of corrective destruction.

In fact, the whole idea of defacing religious works of art does not show up anywhere at all before the early eighth century, when Christians in Armenia and Asia Minor had the idea of eliminating holy images. Until then, iconoclasm, or iconophobia, was a form of fanaticism whose time had not yet come. Representational figures, as opposed to decorative designs, were equally at home in Judaism, Christianity, and Islam before the eighth century. Although the rabbis were concerned about the implications of images, they were generally not fanatical in banning them. The Christians accepted them with equanimity, as the mass of mosaics illustrated here shows so well. And even the Muslims had no ban on representations of living creatures in the holy Qur'ān.

Chronologically, then, the first stirrings of iconoclasm, as far as we know, occurred among the Christians in the Byzantine Empire, when the Near East was no longer a part of it. Despite the impassioned efforts of iconophiles to place the blame for the fanaticism of their coreligionists on others, Arab or Jew, there is no solid testimony in support of this. Yazid was perfectly capable of formulating an edict on his own, but in

the century down to his caliphate Arabs had a special regard for the holy places they had taken over—certainly churches, and probably synagogues as well. It is hard to resist the idea that Yazid may have become aware of the controversy beyond his borders and found that it fueled his own vision of Islam. It would not be the first or the last time that a personal interpretation of Islam had violent practical consequences.

Viewed, therefore, across the continuum of late antiquity, stretching from Constantine all the way into the early Islamic period, the abundant mosaics in the Near East not only illustrate the society of the age, as we know it from literary texts, but extend and enrich our knowledge of it. From these images the uses of Hellenism among Jews, Christians, and pagans alike emerge with clarity. The mosaics put before our eyes the entertainments of mime and pantomime, as persons of all religious convictions savored them. They put on parade the great urban centers, with their own distinctive physical and cultural character, as places in a greater community of shared traditions. The coherence and tolerance in this disparate world explain the deep peace that most of Palestine, Syria, and Transjordan enjoyed over many centuries. The Persian raids in northern Syria and the internecine revolts of Samaritans against the Jews disrupted this peace on occasion, but never in a way that convulsed the whole region. The late-antique Near East was a kind of miracle, and its like has never been seen in that region again. Its culture was so deeply rooted that it even managed to hold on for a hundred years or more after it fell out of the orbit of Constantinople, and its first Umayyad rulers were admirably canny in not trying to wipe out what they had found there. The scribes at Nessana were still writing their papyri in Greek toward the end of the seventh century, more than a hundred years after the Greek papyri at Petra.[10] In the next century the Christians of Mefaa used Greek in their church mosaics, and they even dated their works by the ancient era of the Province of Arabia instead of the year of their Lord.

10. Kraemer Jr., *Excavations at Nessana*, 1958.

BIBLIOGRAPHY

LIST OF ILLUSTRATIONS

INDEX

Bibliography

Alexander, P. J. "An Ascetic Sect of Iconoclasts in Seventh-Century Armenia." In
K. Weitzmann, ed., *Late Classical and Medieval Studies in Honor of Albert
Matthias Friend, Jr.* Princeton: Princeton University Press, 1955. Pp. 151–160.

Athanassiadi, P. "Ascent to Heroic or Divine Status in Late Antiquity: Continuities and Transformations." In *Thesaurus Cultus et Rituum Antiquorum*. Los
Angeles: Getty Museum, 2004. Pp. 212–214.

Avi-Yonah, M. *The Madaba Mosaic Map.* Jerusalem: Israel Exploration Society,
1954.

Balty, Janine. *La mosaïque de Sarrîn (Osrhoène).* Institut Français d'Archéologie
du Proche-Orient, Bibliothèque Archéologique et Historique, vol. 140. Paris:
Geuthner, 1990.

———— *Mosaïques antiques du Proche-Orient.* Centre de Recherches d'Histoire
Ancienne, vol. 140; Annales Littéraires de l'Université de Besançon, 551.
Paris: Les Belles Lettres, 1995.

———— and Briquel Chatonnet, Françoise. "Nouvelles mosaïques inscrites
d'Osrhoène." In *Monuments et Mémoires.* Fondation Eugène Piot, vol. 79.
Paris: Académie des Inscriptions et Belles-Lettres, 2000. Pp. 31–72.

Balty, Jean-Charles. "Une version orientale méconnue du mythe de Cassiopée."
In Lilly Kahil and Christian Augé, eds., *Mythologie gréco-romaine, mythologies*

périphériques: Etudes d'iconographie. Colloques Internationaux du CNRS, no. 593. Paris: Editions du CNRS, 1981. Pp. 95–106.

Barber, Charles, "The Truth in Painting: Iconoclasm and Identity in Early-Medieval Art." *Speculum,* 72 (1997), 1019–36.

———— *Figure and Likeness: On the Limits of Representation in Byzantine Iconoclasm.* Princeton: Princeton University Press, 2002.

Barnard, L. W. *The Graeco-Roman and Oriental Background of the Iconoclastic Controversy.* Leiden: Brill, 1974.

Barnes, T. D. "Christians and the Theater." In W. J. Slater, ed., *Roman Theater and Society.* Ann Arbor: University of Michigan Press, 1996. Pp. 161–180.

Bashear, S. "Qibla Musharriqa and Early Muslim Prayer in Churches." *Muslim World,* 81 (1991), 267–282.

Beaucamp, J.; F. Briquel Chatonnet; and C. J. Robin. "La Persécution des chrétiens de Nagrān et la chronologie himyarite." *ARAM,* 11–12 (1999–2000), 15–83.

Bergmann, Marianne. *Chiragan, Aphrodisias, Konstantinopel: Zur mythologischen Skulptur der Spätantike.* Wiesbaden: Reichert Verlag, 1999.

Blümel, W. "Epigramm auf einen Sieger in Eurhythmie." *Epigraphica Anatolica,* 37 (2004), 20–22.

Bowersock, G. W. "An Arabian Trinity." In G. Nickelsburg and G. MacRae, eds., *Christians among Jews and Gentiles: Essays in Honor of Krister Stendahl.* Philadelphia: Fortress, 1986. Pp. 17–21.

———— *Hellenism in Late Antiquity.* Ann Arbor and Cambridge: University of Michigan Press and Cambridge University Press, 1990.

———— "Polytheism and Monotheism in Arabia and the Three Palestines." *Dumbarton Oaks Papers,* 51 (1997). Reprinted in Bowersock, *Selected Papers on Late Antiquity,* 2000. Pp. 135–147.

———— "The Rich Harvest of Near Eastern Mosaics." *Journal of Roman Archaeology,* 11 (1998), 693–699. Reprinted in Bowersock, *Selected Papers on Late Antiquity,* 2000. Pp. 149–158.

———— "Urheber konkurrierender transzendentaler Visionen in der Spätantike." In Bowersock, *Selected Papers on Late Antiquity,* 2000. Pp. 83–91.

———— *Selected Papers on Late Antiquity.* Bari: Edipuglia, 2000.

———— "Notes on the New Edessene Mosaic of Prometheus." *Hyperboreus,* 7 (2001, published 2002), fasc. 1–2, 411–416.

———— "The Mosaic Inscription in the Nile Festival Building at Sepphoris: The House of the Daughter of the Governor Procopius (A.D. 517–518?) and Her Husband Asbolius Patricus." *Journal of Roman Archaeology,* 17 (2004), 764–766.

———— "The Ḥaḍramawt between Persia and Byzantium." In *La Persia e Bisanzio.* International Congress, Rome, October 2002. Rome: Accademia Nazionale dei Lincei, 2004. Pp. 263–273.

Brown, Peter. "Aspects of the Iconoclastic Controversy." *English Historical Review,* 88 (1973), 1–34. Reprinted in Brown, *Society and the Holy in Late Antiquity.* Berkeley: University of California Press, 1982. Pp. 251–301.

Bruneau, Philippe. "Perspectives sur un domaine encore mal exploré de l'art antique." *Revue des Etudes Grecques,* 79 (1966), 704–726.

Bühl, Gudrun. *Constantinopolis und Roma: Stadtpersonifikationen der Spätantike.* Zurich: Akanthus, 1995.

Cameron, Alan. *Greek Mythography in the Roman World.* New York: Oxford University Press, 2004.

Chuvin, P. *Mythologie et géographie dionysiaques: Recherches sur l'oeuvre de Nonnos de Panopolis.* Clermont-Ferrand: Adosa, 1991.

Crone, P. "Islam, Judea, Christianity, and Byzantine Iconoclasm." *Jerusalem Studies in Arabic and Islam,* 2 (1980), 59–95.

Dagron, Gilbert. *Naissance d'une capitale: Constantinople et ses institutions de 330 à 451.* Paris: Presses Universitaires de France, 1974.

———— *Constantinople imaginaire: Etudes sur le recueil des Patria.* Paris: Presses Universitaires de France, 1984.

Dauphin, Claudine. *La Palestine byzantine: Peuplement et populations.* Oxford: Archaeopress / Hadrian Books, 1998.

Delvoye, C. "La Légende d'Achille au Bas-Empire." *Antiquité Classique,* 53 (1984), 184–199.

De Simone, Adalgisa, and Giuseppe Mandalà. *L'immagine araba di Roma: I geografici del Medioevo.* Bologna: Pàtron, 2002.

Di Segni, L. "Greek Inscriptions in the Nile Festival Building." In J. H.

Humphrey, ed., *The Roman and Byzantine Near East*, vol. 3. *Journal of Roman Archaeology* supplementary series, no. 49. Portsmouth, R.I.: Journal of Roman Archaeology, 2002. Pp. 91–100.

———— "The Mosaic Inscription in the Nile Festival Building at Sepphoris." *Journal of Roman Archaeology*, 18 (2005), 781–784.

Dothan, M. "The Synagogue at Hammath Tiberias." In Lee I. Levine, ed., *Ancient Synagogues Revealed*. Jerusalem: Israel Exploration Society, 1982. Pp. 63–69.

———— *Hammath Tiberias: Early Synagogues and the Hellenistic and Roman Remains*. Final Excavation Report, vol. 1. Jerusalem: Israel Exploration Society, 1983.

Downey, Glanville. *A History of Antioch in Syria*. Princeton: Princeton University Press, 1961.

Dunbabin, K. *Mosaics of the Greek and Roman World*. Cambridge: Cambridge University Press, 1999.

———— and M. Dickie. "Mosaics and Their Public." In Mongi Ennaïfer and Alain Rebourg, eds., *La Mosaïque gréco-romaine 7*. Seventh International Colloquium on the Study of Classical Mosaics, Tunis, October 3–7, 1994. Tunis: Institut National du Patrimoine, 1999. Pp. 741–745.

Elsner, Jaś. "Archaeologies and Agendas: Reflections on Late Ancient Jewish Art and Early Christian Art." *Journal of Roman Studies*, 93 (2003), 114–128.

Feissel, Denis. "L'Epigraphie des mosaïques d'églises en Syrie et au Liban." *Antiquité Tardive*, 2 (1994), 285–291.

Fiema, Z. T.; C. Kanellopoulos; T. Waliszewski; and R. Schick. *The Petra Church*. Amman: American Center of Oriental Research, 2001.

Fine, Steven. "Iconoclasm and the Art of the Late-Antique Palestinian Synagogues." In Lee I. Levine and Zeev Weiss, eds., *From Dura to Sepphoris*. Portsmouth, R.I.: Journal of Roman Archaeology, 2000. Pp. 183–194.

———— *Art and Judaism in the Greco-Roman World: Toward a New Jewish Archaeology*. Cambridge: Cambridge University Press, 2005.

Fowden, Garth. *Qusayr 'Amra: Art and the Umayyad Elite in Late Antique Syria*. Berkeley: University of California Press, 2004.

———— and Elizabeth Key Fowden. *Studies on Hellenism, Christianity and the Umayyads*. Meletemata, 37. Athens: KERA, 2004.

Frantz, Alison. *The Athenian Agora, Vol. 24: Late Antiquity, A.D. 267–700.* Princeton: American School of Classical Studies at Athens, 1988.

Friedländer, Paul, ed. *Spätantiker Gemäldezyklus in Gaza: Des Prokopios von Gaza Ekphrasis eikonos.* Vatican City: Biblioteca Apostolica Vaticana, 1939.

Frösen, Jaakko, and Zbigniew T. Fiema eds. *Petra: A City Forgotten and Rediscovered.* Helsinki: Amos Anderson Art Museum, 2002.

————, Antti Arjava, and Marjo Lehtinen. *The Petra Papyri I.* Amman: American Center of Oriental Research, 2002.

Gatier, Pierre-Louis. *Inscriptions de la Jordanie,* vol. 2. Inscriptions Grecques et Latines de la Syrie, 21. Paris: Geuthner, 1986.

Germer-Durand, J. *La Carte Mosaïque de Madaba.* Paris: Maison de la Bonne Presse, 1897.

Grabar, André. *L'Iconoclasme byzantin.* 2nd ed. Paris: Flammarion, 1984.

Grabar, Oleg. "Islam and Iconoclasm." In Anthony Bryer and Judith Herrin, eds., *Iconoclasm: Papers Given at the Ninth Spring Symposium of Byzantine Studies, University of Birmingham, March 1975.* Birmingham, U.K.: Centre for Byzantine Studies, University of Birmingham, 1977. Pp. 45–52. Reprinted in Oleg Grabar, ed., *Early Islamic Art, 650–1100,* vol. 1. Aldershot: Ashgate, 2005. Pp. 43–56.

Habicht, Christian. "Neue Inschriften aus Demetrias." In V. Milojčić and D. Theocharis, eds., *Demetrias,* vol. 5. Bonn: Habelt, 1987. Pp. 269–306.

Herzfeld, Ernst. *Die Malereien von Samarra.* Berlin: Reimer, 1927.

Hirschfeld, Yizhar. *The Roman Baths of Hammat Gader.* Jerusalem: Israel Exploration Society, 1997.

Hommel, Hildebrecht. *Der Gott Achilleus.* Sitzungsberichte der Heidelberger Akademie der Wissenschaften, Philosophisch-Historische Klasse. Heidelberg: Winter, 1980.

Hoyland, Robert. Review of Robert Schick, *The Christian Communities of Palestine,* 1995. *Bulletin of the School of Oriental and African Studies,* 61 (1998), 329–330.

Janin, Raymond. *Constantinople byzantine: Développement urbain et répertoire topographique.* Paris: Institut Français d'Etudes Byzantines, 1964.

Jones, C. P. *Culture and Society in Lucian.* Cambridge, Mass.: Harvard University Press, 1986.

Joukowsky, Martha Sharp. *Petra: Great Temple,* vol. 1. Brown University Excavations, 1993–1997. Providence, R.I.: M. Joukowsky, 1998.

Koenen, Ludwig; Robert W. Daniel; and Traianos Gagos. "Petra in the Sixth Century: The Evidence of the Carbonized Papyri." In Glenn Markoe, ed., *Petra Rediscovered.* New York: Harry Abrams and the Cincinnati Art Museum, 2003. Pp. 250–261.

Koikylidis, Kleopas. Ο εν Μαδηβα μωσαϊκός καί γεωγραφικός κτλ. Jerusalem, 1897.

Kondoleon, Christine, et al. *Antioch: The Lost Ancient City.* Exhibition catalogue. Princeton: Princeton University Press and Worcester Art Museum, 2000.

Kraemer Jr., Casper J. *Excavations at Nessana, Vol. 3: Non-Literary Papyri.* Princeton: Princeton University Press, 1958.

Kühnel, Bianca. "The Synagogue Floor Mosaic in Sepphoris: Between Paganism and Christianity." In Lee I. Levine and Zeev Weiss, eds., *From Dura to Sepphoris.* Portsmouth, R.I.: Journal of Roman Archaeology, 2000. Pp. 31–43.

Lagrange, M.-J. "La Mosaïque géographique de Madaba." *Revue Biblique,* 6 (1897), 165–184.

———— "Jérusalem d'après la mosaïque de Madaba." *Revue Biblique,* 6 (1897), 450–458.

Leader-Newby, Ruth E. *Silver and Society in Late Antiquity: Functions and Meanings of Silver Plate in the Fourth to Seventh Centuries.* Aldershot: Ashgate, 2004.

Levi, D. *Antioch Mosaic Pavements.* 2 vols. Princeton: Princeton University Press, 1947.

Levi, M., and A. Levi. *Itineraria Picta.* Rome: Bretschneider, 1967.

Levine, Lee I., and Zeev Weiss, eds. *From Dura to Sepphoris: Studies in Jewish Art and Society in Late Antiquity. Journal of Roman Archaeology* supplementary series, no. 40. Portsmouth, R.I.: Journal of Roman Archaeology, 2000.

MacCoull, L. S. B. *Dioscorus of Aphrodito: His Work and His World.* Berkeley: University of California Press, 1988.

Malineau, V. "L'apport de *l'Apologie des mimes* de Chorikios de Gaza à la connaissance du théâtre du VIe siècle." In C. Saliou, ed., *Gaza dans l'Antiquité Tardive: Archéologie, rhétorique et histoire.* Salerno: Helios, 2005. Pp. 149–169.

Mango, Cyril, and Roger Scott. *The Chronicle of Theophanes Confessor.* Oxford: Clarendon, 1997.

Mango, Marlia. *The Sevso Treasure: A Collection from Late Antiquity—The Property of the Trustee of the Marquess of Northampton Settlement.* Auction catalogue. New York, Zurich, and London: Sotheby's, February 1990.

Markoe, Glenn, ed. *Petra Rediscovered.* New York: Harry Abrams and the Cincinnati Art Museum, 2003.

Merkelbach, R., and J. Stauber, eds. *Steinepigramme aus dem griechischen Osten,* Vol. 4: *Die Südküste Kleinasiens, Syrien und Palaestina.* Munich: Saur, 2002.

Moss, C. "Jacob of Serugh's Homilies on the Spectacles of the Theatre." *Le Muséon,* 48 (1935), 87–112.

Muth, Susanne. *Erleben von Raum—Leben im Raum: Zur Funktion mythologischer Mosaikbilder in der römisch-kaiserzeitlichen Wohnarchitektur.* Heidelberg: Archäologie und Geschichte, 1998.

Ognibene, Susanna. *La chiesa di Santo Stefano ad Umm al-Rasas: Il problema iconofobico.* Rome: Bretschneider, 2002.

Parrish, David. "A Mythological Theme in the Decoration of Late Roman Dining Rooms: Dionysos and His Circle." *Revue archéologique* (1995), 307–332.

Piccirillo, Michele. *Madaba: Le chiese e i mosaici.* Milan: Paoline, 1989.

———— *The Mosaics of Jordan.* Ed. Patricia M. Bikai and Thomas A. Dailey. Amman: American Center of Oriental Research, 1993.

———— *L'Arabia cristiana, dalla provincia imperiale al primo periodo islamico.* Milan: Jaca, 2002.

———— with J. Balty; G. Bisheh; H. Buschhausen; N. Duval; R. Farioli Campanati; and P. Testini. *Mosaïques byzantines de Jordanie.* Lyon: Musée de la Civilisation Gallo-Romaine de Lyon, 1989.

Piccirillo, Michele, with Eugenio Alliata et al. *Umm al-Rasas, Mayfa'ah I: Gli scavi del complesso di Santo Stefano.* Jerusalem: Studium Biblicum Franciscanum, 1994.

Piccirillo, Michele, with Eugenio Alliata. *The Madaba Map Centenary, 1897–1997.* Proceedings of the international conference held in Amman, April 7–9, 1997. Jerusalem: Studium Biblicum Franciscanum, 1999.

Politis, Konstantinos. "Excavating Lot's Sanctuary in Jordan." *Minerva,* 3 (July–August 1992), 6–9.

Rabbat, Nasser. *The Citadel of Cairo: A New Interpretation of Royal Mamluk Architecture.* Leiden: Brill, 1995.

Robert, Louis. "Pantomimen im griechischen Osten." *Hermes,* 30 (1930), 106–122. Reprinted in *Opera Minora Selecta,* I:654–670.

——— "ΑΡΧΑΙΟΛΟΓΟΣ." *Revue des Etudes Grecques,* 36 (1936), 235–254. Reprinted in *Opera Minora Selecta,* I:671–690.

Rostovtzeff, Michael I., et al. *The Excavations at Dura-Europos.* Preliminary Report of the 1932–1933 season of excavation at the site. New Haven: Yale University Press, 1936.

Roueché, Charlotte. *Performers and Partisans at Aphrodisias in the Roman and Late Roman Periods.* London: Society for the Promotion of Roman Studies, 1993.

Scherrer, Peter. *Ephesos: Der neue Führer.* Vienna: Austrian Archaeological Institute, 1995.

Schick, R. "Christianity in the Patriarchate of Jerusalem in the Early Abbasid Period, 132–198 / 750–813." *Proceedings of the Fifth International Conference on the History of Bilād al-Shām.* Amman, 1991. Pp. 63–80.

——— *The Christian Communities of Palestine from Byzantine to Islamic Rule.* Studies in Late Antiquity and Early Islam, 2. Princeton: Darwin Press, 1995.

Schwartz, Seth. "On the Program and Reception of the Synagogue Mosaics." In Lee I. Levine and Zeev Weiss, eds., *From Dura to Sepphoris.* Portsmouth, R.I.: Journal of Roman Archaeology, 2000. pp. 165–181.

Shahîd, Irfān. *The Martyrs of Najrān: New Documents.* Subsidia Hagiographica, no. 49. Brussels: Société des Bollandistes, 1971.

Slater, W. J., ed. *Roman Theater and Society.* E. Togo Salmon Papers, I. Ann Arbor: University of Michigan Press, 1996.

Smith, R. R. R., and C. Ratté. "Archaeological Research at Aphrodisias in Caria." *American Journal of Archaeology,* 101 (1977), 1–22.

Sukenik, E. L. *The Ancient Synagogue of Beth Alpha.* Jerusalem: Jerusalem University Press, 1932.

Talgam, R., and Z. Weiss. *The Mosaics of the House of Dionysus at Sepphoris.* Jerusalem: Institute of Archaeology, 2004.

Theocharidis, G. J. *Beiträge zur Geschichte des byzantinischen Profantheaters im IV. und V. Jahrhundert, hauptsächlich auf Grund der Predigten des Johannes Chrysostomos, Patriarchen von Constantinopel.* Thessaloniki: Triantaphyllou, 1940.

Vasiliev, A. A. "The Iconoclastic Edict of the Caliph Yazid II, A.D. 721."
Dumbarton Oaks Papers, 9–10 (1956), 25–47.

Vinogradov, Yuri, and S. A. Shestakov. "Laudatio Funebris iz Pantikapeya."
Vestnik Drevnei Istorii, 2, no. 253 (2005), 42–44. With commentary by S. Y.
Saprykin, pp. 45–81.

Weber, Ekkehard. *Tabula Peutingeriana: Codex Vindobonensis 324.* 2 vols., facsim-
ile and commentary. Graz: Akademische Druck- und Verlagsanstalt, 1976.

Weiss, Zeev, and R. Talgam. "The Nile Festival Building and Its Mosaics: Mytho-
logical Representations in Early Byzantine Sepphoris." In J. H. Humphrey,
ed., *The Roman and Byzantine Near East,* vol. 3. *Journal of Roman Archaeology*
supplementary series, no. 49. Portsmouth, R.I.: Journal of Roman Archaeol-
ogy, 2002. Pp. 55–90.

Weiss, Zeev, with contributions by Ehud Netzer et al. *The Sepphoris Synagogue:
Deciphering an Ancient Message through Its Archaeological and Socio-Historical
Contexts.* Jerusalem: Israel Exploration Society, 2005.

Weitzmann, Kurt. *The Place of Book Illustration in Byzantine Art.* Princeton:
Princeton University Press, 1975.

Zanker, Paul, and Björn Christian Ewald. *Mit Mythen leben: Die Bilderwelt der
römischen Sarkophage.* Munich: Hirmer, 2004.

Zayadine, Fawzi. "Peintures murales et mosaïques à sujets mythologiques en
Jordanie." In Lilly Kahil, Christian Augé, and Pascale Linant de Bellefonds,
eds., *Iconographie classique et identités régionales. Bulletin de Correspondance
Hellénique,* suppl. 14. Paris: De Boccard, 1986. Pp. 407–428.

Zayyat, H. "Al-diyārāt al-naṣrānīya fī 'l-islām." *Al-Machriq,* 36 (1938).

Z'ubi, I.; P.-L. Gatier; M. Piccirillo; and J. Seigne. "Note sur une mosaïque à
scène bachique dans un palais d'époque byzantine à Jérash." *Liber Annuus,*
44 (1994), 539–546.

List of Illustrations

1.1. The first photograph of the Madaba map, taken by J. Germer-Durand in March 1897. Reproduced in M. Piccirillo, *Madaba,* 1989, p. 76. *2*

1.2. Bacchant and satyr, Archaeological Museum at Madaba. Courtesy of M. Piccirillo, Archive of the Studium Biblicum Franciscanum, Jerusalem. *3*

1.3. Room of Hippolytus, Church of the Virgin, Madaba. Courtesy of M. Piccirillo, Archive of the Studium Biblicum Franciscanum, Jerusalem. *8*

1.4. Esquiline statuettes of Rome, Constantinople, Antioch, and Alexandria. Trustees of the British Museum. *10*

1.5. Mosaic of Alexandria, Church of St. John, Gerasa (Jerash). From R. Schick, *The Christian Communities of Palestine from Byzantine to Islamic Rule* (Princeton: Darwin Press, 1995); courtesy of R. Schick. *11*

1.6. Overview of the great mosaic in the Church of St. Stephen, Umm er-Rasas. Courtesy of M. Piccirillo, Archive of the Studium Biblicum Franciscanum, Jerusalem. *13*

1.7. The Madaba map. From Michael Avi-Yonah, *The Madaba Mosaic Map* (Jerusalem: Jewish Exploration Society, 1954). *14*

1.8. Vignette of Jerusalem with adjacent cities, Madaba map. From Michael Avi-Yonah, *The Madaba Mosaic Map* (Jerusalem: Jewish Exploration Society, 1954). *16*

1.9. Peutinger Table: vignette of Rome. *Tabula Peutingeriana, Codex Vindobonensis 324: Vollständige Faksimile-Ausgabe im Originalformat* (Graz: Akademische Druck- und Verlagsanstalt, 1976). *20*

1.10. Peutinger Table: vignette of Antioch. *Tabula Peutingeriana, Codex Vindobonensis 324: Vollständige Faksimile-Ausgabe im Originalformat* (Graz: Akademische Druck- und Verlagsanstalt, 1976). *21*

1.11. Peutinger Table: vignette of Constantinople. *Tabula Peutingeriana, Codex Vindobonensis 324: Vollständige Faksimile-Ausgabe im Originalformat* (Graz: Akademische Druck- und Verlagsanstalt, 1976). *22*

1.12. Mosaic of Gadoron, Church of the Acropolis, Ma'in. From R. Schick, *The Christian Communities of Palestine from Byzantine to Islamic Rule* (Princeton: Darwin Press, 1995); courtesy of R. Schick. *24*

1.13. Unknown cities west of Mampsis in the Negev, Madaba map. From Michael Avi-Yonah, *The Madaba Mosaic Map* (Jerusalem: Jewish Exploration Society, 1954). *27*

2.1. Crowning of Cassiopeia, New Paphos, Cyprus. Courtesy of Vassos Karageorghis. *34*

2.2. Hospital mosaic with Romulus and Remus, Museum at Ma'arat an-Numan. Courtesy of Nasser Rabbat. *36*

2.3. Mosaic of centaur from the Nile Festival Building at Sepphoris. Courtesy of Zeev Weiss, Sepphoris Expedition, Hebrew University of Jerusalem. *37*

2.4. Mosaic of Prometheus from Edessa. Private collection; photo courtesy of J. Balty and F. Briquel Chatonnet. *38*

2.5. Drinking bout of Heracles and Dionysus, House of the Patriarch (?), Sepphoris. Courtesy of Zeev Weiss, Sepphoris Expedition, Hebrew University of Jerusalem. *40*

2.6 Mosaic of Dionysus and Heracles with surrounding panels, Sepphoris. Courtesy of Zeev Weiss, Sepphoris Expedition, Hebrew University of Jerusalem. *41*

2.7. Drinking bout of Heracles and Dionysus, Antioch. Courtesy of Christine Kondoleon, Worcester Art Museum. *42*

2.8. Hermes holding the baby Dionysus, New Paphos, Cyprus. Courtesy of Vassos Karageorghis. *43*

2.9 Apollo with lyre, New Paphos, Cyprus. Courtesy of Vassos Karageorghis. *44*

2.10. Dionysus and Ariadne, textile, Abegg Foundation. Photo by H. Kobi; © Abegg Stiftung, 1987. *45*

2.11. Pan and nurse, textile, Abegg Foundation. Photo by H. Kobi; © Abegg Stiftung, 1987. *46*

2.12. Mosaic of Dionysus, Sarrin. Photo by Marc Balty, 1990; courtesy of Janine Balty. *47*

2.13. Mosaic of Thalassa (the sea), Church of the Apostles, Madaba. Courtesy of M. Piccirillo, Archive of the Studium Biblicum Franciscanum, Jerusalem. *48*

2.14. Mosaic of Achilles and Patroclus, Madaba. Courtesy of M. Piccirillo, Archive of the Studium Biblicum Franciscanum, Jerusalem. *49*

2.15. Central medallion, Augst silver platter, Switzerland. Courtesy of the Roman Museum at Augst (formerly Kaiseraugst). *51*

2.16. Achilles, silver platter, Sevso Treasure. Courtesy of the Trustee of the Marquess of Northampton 1987 Settlement. *52*

2.17. Personification of Comedy, with the author Menander and his mistress Glycera, Antioch. Photo by Bruce M. White; courtesy of the Princeton University Art Museum, gift of the Committee for the Excavation of Antioch. *54*

2.18. Phaedra and Hippolytus, Sheikh Zwed. Originally published by Jean Clédat, in *Annuaire du service des Antiquités d'Egypte,* 15 (1915), plates 3–4 and fig. 5 (facsimile). *57*

2.19. Amazons, Nile Festival Building, Sepphoris. Courtesy of Zeev Weiss, Sepphoris Expedition, Hebrew University of Jerusalem. *61*

3.1. Mosaic vignette of Kastron Mefaa in the Church of the Lions, Umm er-Rasas, with cross on the column. Courtesy of M. Piccirillo, Archive of the Studium Biblicum Franciscanum, Jerusalem. *67*

3.2. Mosaic vignette of Kastron Mefaa from the eighth century, Church of St. Stephen, without cross. Courtesy of M. Piccirillo, Archive of the Studium Biblicum Franciscanum, Jerusalem. *68*

3.3. Excavated site of Mefaa, Umm er-Rasas. Courtesy of M. Piccirillo, Archive of the Studium Biblicum Franciscanum, Jerusalem. *69*

3.4. Modern tower at Umm er-Rasas. Courtesy of M. Piccirillo, Archive of the Studium Biblicum Franciscanum, Jerusalem. *70*

3.5. Upper part of the city mosaic at the Church of St. Stephen, Umm er-Rasas. Courtesy of M. Piccirillo, Archive of the Studium Biblicum Franciscanum, Jerusalem. *71*

3.6. The Holy City (Hagia Polis): Jerusalem in the mosaic at the Church of St. Stephen, Umm er-Rasas. Courtesy of M. Piccirillo, Archive of the Studium Biblicum Franciscanum, Jerusalem. *74*

3.7. Characmoba (Kerak), in the mosaic of the Church of St. Stephen, Umm er-Rasas. Courtesy of M. Piccirillo, Archive of the Studium Biblicum Franciscanum, Jerusalem. *76*

3.8. Neapolis (Nablus), on the mosaic of the Church of St. Stephen, Umm er-Rasas. Courtesy of M. Piccirillo, Archive of the Studium Biblicum Franciscanum, Jerusalem. *78*

3.9. Nilotic scenes from the mosaic of the Church of St. Stephen, Umm er-Rasas. Courtesy of M. Piccirillo, Archive of the Studium Biblicum Franciscanum, Jerusalem. *79*

3.10. The personified cities *(tychai)* of Rome, Gregoria, and Madaba in the mosaic from the Room of Hippolytus, Madaba. Courtesy of M. Piccirillo, Archive of the Studium Biblicum Franciscanum, Jerusalem. *82*

3.11. Mosaic with defaced cities *(tychai)* from the Church of Wa'il, Umm er-Rasas. Courtesy of M. Piccirillo, Archive of the Studium Biblicum Franciscanum, Jerusalem. *83*

3.12. Graffito of *tychai* on a wall at Aphrodisias in Caria. Courtesy of Charlotte Roueché and the New York University Aphrodisias Archive. *83*

4.1. The mosaic at Beth Alpha, as drawn by E. L. Sukenik. From E. L. Sukenik, *The Ancient Synagogue of Beth Alpha* (Jerusalem: Hebrew University, 1932). *94*

4.2. Defaced figures with small cities in the mosaic at the Church of St. Stephen, Umm er-Rasas. Courtesy of M. Piccirillo, Archive of the Studium Biblicum Franciscanum, Jerusalem. *100*

4.3. Defaced animal in the mosaic at the Church of St. George, Gerasa (Jerash). From R. Schick, *The Christian Communities of Palestine from Byzantine to Islamic Rule* (Princeton: Darwin Press, 1995); courtesy of R. Schick. *101*

4.4. The mosaic at Na'aran, with iconoclastic damage. From E. L. Sukenik, *An-*

cient Synagogues in Palestine and Greece (Oxford: Oxford University Press, 1934). ***102***

4.5. The zodiac mosaic from the synagogue at Sepphoris. Courtesy of Zeev Weiss, Sepphoris Expedition, Hebrew University of Jerusalem. ***107***

5.1. Vignette of Areopolis (Rabba) from the mosaic in the Church of St. Stephen, Umm er-Rasas. Courtesy of M. Piccirillo, Archive of the Studium Biblicum Franciscanum, Jerusalem. ***118***

Elsner, Jaś 95
Elusa, 25
Ephesus, 17, 28, 32
Erotes, 7, 58, 66, 105
Erouta, 25
Esbous, 10, 23
Esquiline, silver treasure, 9, 23
Ethiopia, 111
Europa, 32, 43, 55
Eusebius, of Caesarea, 17, 19, 25, 26, 28
Eutychius, of Alexandria, 109
Evagrius, 87

Feissel, Denis, 4
Fine, Steven, 93, 98, 108
Fowden, Garth, 32
Friedländer, Paul, 56
Fulghum, Mary Margaret, 82

Gadoron, 10, 23–24
Galgala, 26, 66
Gallus (usurper in fourth century), 115
Garizim, 25, 26, 77
Gatier, Pierre-Louis, 17, 87
Gaza, 32, 56, 58, 62, 73, 75
Genesis, book of, 19
George, of Cyprus, 28
George, St.: Church of (Madaba), 1; Church of
 (Gerasa), 103
Georgius (monk), 98, 105
Gerara, 26
Gerasa, 5, 9, 10, 13, 23, 65, 69, 75, 80, 95,
 106
Germanus (patriarch of Constantinople), 96
Gethsemane, 109
Golgotha, 109
Grabar, André, 91, 104
Graces, 7
Gregoria (city), 8, 9, 28, 31, 81–88
Gregoria (monastery), 84
Gregoria (monk), 84–85
Gregorius (patriarch), 87, 119

Habicht, Christian, 19
Hadrian (emperor), 114
Hammat Gader, 4
Hammat Tiberias, 106, 107, 119
Helios, 93, 107, 108
Hellenism, 5, 111, 115, 117, 122
Hera, 36
Heracleopolis, 79
Heracles, 7, 39–41, 43, 45, 50, 53, 55, 56, 62, 119
Hermes, 39, 41
Herod, the Great, 115
Herodotus, 115–116
Heshbon, 75
Hiereia, council of, 96, 103
Hippolytus, 7, 31, 32, 56–59, 81, 87, 105
Hisham, 97, 98, 110
Holy Sepulchre, Church of (Jerusalem). See
 Anastasis
Homer, 53
Hoyland, Robert, 110

Iconophobia, 6
Iraq, 109
Islam, 5, 121. See also Muslims
Israel, 13

Jacob: his ladder, 19; his well, 26
Jacob, of Sarug, 55, 61–62
Jerash. See Gerasa
Jericho, 108
Jerusalem, 13, 18, 25, 66, 73, 74, 79–80, 86, 103,
 105, 109, 114
Jesus, Christ, 62, 69, 92
Jews, and Judaism, 5, 6, 39, 92, 93–95, 98–99,
 106–110, 116, 117, 121
John, Chrysostom, 55
John, of Damascus, 98, 103
John, of Jerusalem, 104, 109
John, St.: Church of (Gerasa), 10, 23; Church of
 (Samra), 10
John, the presbyter, 104–105
Jones, Christopher, 50

Jordan (kingdom), 1, 4, 5, 6, 35
Jordan (river), 26, 73
Judaea, 18, 115
Julian (emperor), 114
Justinian, 6, 86–87

Kainoupolis, 26
Kaiseraugst. *See* Augst
Kasion, 79
Kastron Mefaa. *See* Umm er-Rasas
Kerak. *See* Characmoba
Khattab, al-, 'Umar b., 109
Kindi, al-, 98, 104, 105
Kitzinger, Ernst, 106
Kodinos, pseudo-, 84
Koikylidis, Kleopas, 13
Kufa, 109
Kynopolis, 79

Lagrange, M.-J., 17
Leo III (Byzantine emperor), 92, 96, 105
Levi, Doro, 4
Levi, M. and A., 23
Libanius, 9, 32, 55–56, 119
Limbon (Livias, not Libb), 72–73
Lions, Church of the (Umm er-Rasas), 66–67
Livias, 72–73
Lot, St., and Procopius, Church of (Mukhayyat),
 105–106
Lot, St., basilica at Deir 'ain 'Abata, 100–101, 103
Lucian (satirist), 55
Lucius Verus (emperor), 55

Maccabees, 115
Madaba, 1, 4, 7, 8, 9, 11, 31, 32, 35, 44, 48, 52,
 55–58, 60, 63, 72, 75, 81–85, 87
Madaba map, 1, 2, 7, 13, 14–16, 18, 19, 20, 23,
 25, 28, 65–66, 75, 80–81, 85, 114, 120
Ma'in, 5, 9, 10, 13, 23, 69, 80, 101
Malalas, John, 58, 86
Mamluks, 81
Mansur, al- (caliph), 109

Maqrizi, al-, 98
Marsyas, 41
Masuh, 99
Mavia (Māwiyya; Arab queen), 115
Mediterranean, 13, 44
Mefaa. *See* Umm er-Rasas
Menander, 54
Mesopotamia, 36
Mimes, 51, 54–55, 59
Moa, 25
Moses, 19
Mu'awiyya, 109
Mukhayyat, Khirbet al-, 105–106
Muqaddasi, al-, 80
Muqaffa, al-, Severus b., 98, 104
Muslims, 6, 11, 13, 92, 95, 98, 106, 108, 109–111,
 114, 117, 120, 121

Na'aran, 99, 102, 106, 107, 108, 121
Nabataeans, 115, 120
Najrān, 115
Neapolis (Nablus), 26, 64, 73, 77, 78
Nebo, Mount, 72–73
Negev, 13, 25, 27, 109
Nereids, 33
Nessana, in the Negev, 122
Nicaea, Second Council of, 96, 97, 104
Nicephorus (patriarch), 98
Nicopolis (Emmaus), 23
Nikephorion (Callinicum), on the Euphrates, 86
Nikephorion, near Edessa. *See* Tela
Nitla, Khirbet en-, 103
Nonnos (epic poet), 32, 39, 62
Notitia Dignitatum, 10, 66

O'Callaghan, José, 18
Onomasticon, of Eusebius, 17, 18, 19, 25–26, 66
Orontes (river), 23, 85

Palestine, 5, 6, 13, 20, 23, 25, 35, 65, 79, 85, 95,
 98, 108, 110, 115, 120, 122
Palmyra, and Palmyrenes, 5, 33, 35, 63, 115, 116

Pan, 42, 46, 50

Panaou, 79

Pantomimes, 54–55, 59

Paphos, New Cyprus, 33, 39, 63

Patriarch, Christian. *See* Germanus

Patriarch, Jewish, 39–40, 116, 119

Patriarchate (Antioch), 118

Patroclus, 48–50, 52, 60, 63

Pelusium, 13, 79

Penthesilea, 60

Persians, Sassanian, 114, 116

Petra, 75, 119–120, 122

Peutinger Table, 9, 19, 20–22, 25, 82, 86

Phaedra, 7, 32, 55–59, 60, 81

Philadelphia (Amman), 75

Philippopolis, 4, 36

Philistines, 28

Philo, of Byblos, 35

phylarchs, 6

Piccirillo, Michele, 4, 6, 7, 66, 72, 79, 98

Pisga, 73

Poseidon, 33

Praesidium, 25

Proclus, Neoplatonist, 41, 61

Procopius, of Gaza, 28, 32, 56–58

Prometheus, 36, 38

Pseudostomon, 79

Psyche, 36

Ptolemaeus Chennus, 35

Ptolemy (geographer), 26

Pushkin (Russian author), 86

qibla, 109–110

Qur'ān, 96, 121

Quweisma, 101

Rabba. *See* Areopolis

Rabbat, Nasser, 81

Raphidim, 13

Rome (Roma), 8, 9, 20, 28, 31, 81–82, 85, 114, 116; New, or Second, *See* Constantinople

Romulus, and Remus, 34

Samaria Sebaste, 73

Samaritans, 5, 26, 115

Samarra, 97

Samra, Khirbet as-, 9, 13

Sarrin, 4, 31, 42, 43, 45, 47, 53, 63

Sassanians. *See* Persians

Schick, Robert, 72, 93, 95, 98, 101

Schwartz, Seth, 99, 108

Seana, 26

Sebaste (Sebasteia), as city name, 87

Semele, 58

Sepphoris, 37, 39–40, 60–61, 63, 106–107, 116, 119

Septuagint, 19

Sevso, treasure, 51–52, 56

Shahba. See Philippopolis

Sheikh Zwed, 56–57

Skyros, 54

Smyrna, 17, 28, 75

Stephen, St., Church of (Umm er-Rasas), 11–12, 65–81, 101, 103

Suchem (Sichem, Shechem), 19

Sychar, 26

Symmachus, 6

Syria, 4, 5, 6, 17, 20, 28, 34, 42, 65, 85, 88, 115, 122

Syriac, 36, 119

Tatian, 60

Tela (Nikephorion, Constantia), near Edessa, 86

Tessarakontapechus, 97–98

Thalassa (sea), 43–44, 85, 93

Themistius (orator), 85

Theodoret, 28

Theodosius I (emperor), 84

Theophanes, Byzantine chronicler, 97, 105

Theotokos, Church of the (Jerusalem), 109

Theotokos, Church of the (Neapolis), 77

Theoupolis. *See* Antioch, in Syria

Theseus, 32

Thessaly, 19

Thmouis, 26

Thomas, of Claudiopolis (Bithynia), 96

Troy, 60

Tsargrad (Russian name for Constantinople), 86

Ṭûr, 26

Tychai (city fortunes, personifications), 8, 22, 81–
83

Umayyads, 6, 66, 71, 77, 80, 91, 95, 97, 120,
122

Umm er-Rasas (Mefaa), 5, 11, 13, 65–81, 101,
103, 117, 122

Vasiliev, A. A., 95, 97, 104–105

Virgin, Church of the (Madaba), 7, 31, 55, 105

Wa'il, Church of (Umm er-Rasas), 82–83

Walid, 97, 98

Weiss, Zeev, 39

Weitzmann, Kurt, 53, 80

Yakut (geographer), 80

Yazid II (Umayyad caliph), 92, 95, 96, 97, 98, 104,
105, 106, 108, 109, 110, 121–122

Zayadine, Fawzi, 36

Zenobia (Palmyrene queen), 116

Zeus, 36, 61, 62; *hypsistos,* 77

zodiac, 93, 107, 108

Zonaras, 105

REVEALING ANTIQUITY

G. W. Bowersock, General Editor

1. *Dionysos at Large* by Marcel Detienne, translated by Arthur Goldhammer
2. *Unruly Eloquence: Lucian and the Comedy of Traditions* by R. Bracht Branham
3. *Greek Virginity* by Giulia Sissa, translated by Arthur Goldhammer
4. *A Chronicle of the Last Pagans* by Pierre Chuvin, translated by B. A. Archer
5. *The Orientalizing Revolution: Near Eastern Influence on Greek Culture in the Early Archaic Age* by Walter Burkert, translated by Margaret E. Pinder and Walter Burkert
6. *Actors in the Audience: Theatricality and Doublespeak from Nero to Hadrian* by Shadi Bartsch
7. *Prophets and Emperors: Human and Divine Authority from Augustus to Theodosius* by David Potter
8. *Hypatia of Alexandria* by Maria Dzielska
9. *The Craft of Zeus: Myths of Weaving and Fabric* by John Scheid and Jesper Svenbro
10. *Magic in the Ancient World* by Fritz Graf, translated by Franklin Philip
11. *Pompeii: Public and Private Life* by Paul Zanker, translated by Deborah Lucas Schneider
12. *Kinship Diplomacy in the Ancient World* by Christopher P. Jones
13. *The End of the Past: Ancient Rome and the Modern West* by Aldo Schiavone, translated by Margery J. Schneider
14. *The Invention of Jane Harrison* by Mary Beard
15. *Ruling the Later Roman Empire* by Christopher Kelly